IMAGES
of America

CLEVELAND PARK

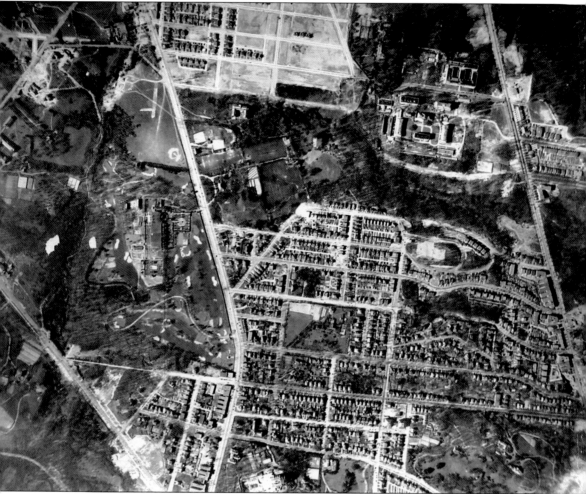

This extremely rare high-altitude image taken by the United States Army Air Corps encompasses all of Cleveland Park. To the west can be seen the Friendship mansion and its accompanying golf course. To the east, Connecticut Avenue appears prior to the well-known landmarks of the Up Town Theater and the Park and Shop. To the south can be seen the mansions of Twin Oaks, Tregaron, and the edge of the Beauvoir estate with its long driveway, in the shadow of the partially completed Cathedral. To the north is the National Bureau of Standards and the uncompleted section of Reno Road and 34th Street. The center of the picture shows the Rosedale estate, next to Red Tops, the summer home of President Grover Cleveland, fronting onto Macomb Street. East of Red Tops can be seen the old John Eaton School and a home at the southeast intersection of Macomb and 34th that has since been razed. Vacant lots abound along Newark and Macomb Streets south of the incomplete section of Ordway Street. Throughout the entire neighborhood are homes and buildings that have passed into history and vacant lots where homes, apartments, and businesses are now located. (NA.)

IMAGES
of America

CLEVELAND PARK

Paul K. Williams and Kelton C. Higgins

ARCADIA
PUBLISHING

Published by Arcadia Publishing
Charleston, South Carolina

Printed in the United States of America

Library of Congress Catalog Card Number: 2003103771

For all general information contact Arcadia Publishing at:
Telephone 843-853-2070
Fax 843-853-0044
E-mail sales@arcadiapublishing.com
For customer service and orders:
Toll-Free 1-888-313-2665

Visit us on the Internet at www.arcadiapublishing.com

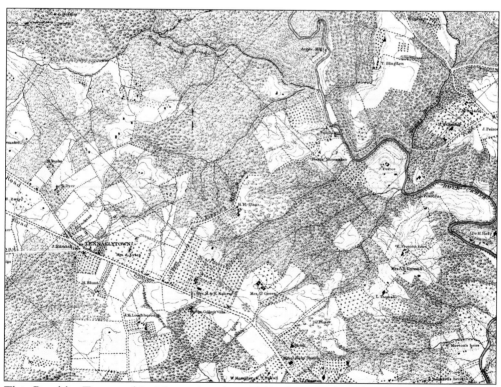

This Boschke Topographic Map, printed in 1861, shows only a few large country estates among the heavily wooded areas that would eventually evolve into the Cleveland Park neighborhood. (CPHS.)

CONTENTS

ACKNOWLEDGMENTS

Many people made the production of this book possible, especially Laura Daniels New at Arcadia Publishing, who kept us on track with deadlines and advice. Thanks to family members, friends, and lovers. Thanks also goes to the staff of the Prints and Photographs Division of the Library of Congress (LOC), Historical Society of Washington (HSW), Judy Hubbard Saul of the Cleveland Park Historical Society (CPHS), the staff of the Washingtoniana Division of the Martin Luther King Jr. Memorial Library (MLK), Diane Ney, Dr. Richard Hewlett, Greg Rixon, and all of the staff at the National Cathedral Archives (NCA), the National Archives (NA), and the Smithsonian.

Additional thanks to Franke Vogl for making Cleveland Park a great place to live and Katherine Brown for assistance in researching this book.

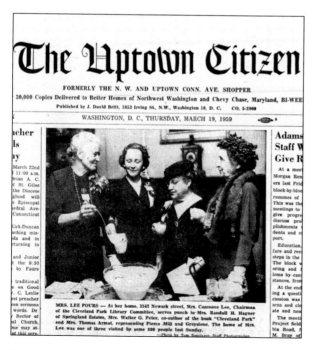

Acknowledgement is also made to the authors of Cleveland Park's first history booklet, who are shown here in 1959 celebrating their accomplishment. A local paper reported, "Cleveland Park's neighborhood party on March 15, 1959 was a huge success, with over 1,000 people visiting Rosedale. It was held to celebrate the Community Library Committee's newly published booklet history entitled "Cleveland Park." Seen here are Mrs. Cazenove Lee, whose house at 3542 Newark was also open to visitors, serving punch to (left to right) Mrs. Randall H. Hagner, Mrs. Walter G. Peter, co-author of the history, and Mrs. Thomas Armat. Descendants of the original settlers of the area were honored guests." (CPHS.)

INTRODUCTION

The neighborhood of Cleveland Park is one of Washington's most beloved, with a history that dates back to the 1790s. Largely forest and agricultural land until the mid-1800s, the area is now a showcase of architectural grandeur and diversity in the nation's capital. Cleveland Park started to take shape in 1790 in the form of a single estate owned by Gen. Uriah Forrest and his business partner, Col. Benjamin Stoddert. They coined it "Pretty Prospects." Forrest bought out his partner in 1794 and renamed the estate Rosedale. The boundaries of Pretty Prospects were roughly from the Sidwell Friends School to Georgetown and from Wisconsin Avenue to Rock Creek Park. This included the modern neighborhoods of Cleveland Park, Woodley Park, Massachusetts Avenue Heights, and Van Ness. Prior to 1802, the area fell within the administrative control of Montgomery County, Maryland and was earlier a portion of a much larger tract of land known as the Rock of Dunbarton owned by the Beall family of Georgetown.

As the original owners of Pretty Prospects sold off large parcels of land over the years, they were bought up by wealthy Washingtonians. The trend mirrored the city's expanding boundaries in the 1890s. The new estates were of unsurpassed architectural quality and variety, and they replaced the estate of Pretty Prospects during the 19th century.

A survey of 1914 shows that there were 33 prominent estates and other significant businesses (such as mills) that had been built within the bounds of the 1790 land grant of Pretty Prospects; 11 of these are located within the boundaries of contemporary Cleveland Park. The oldest of these homes is Rosedale, which dates from 1746. Other estates in Cleveland Park include Cloverdale, the Vineyard, Linnean Hill (also known as Klingle), The Highlands, Springland Farm, Forrest Hill, Twin Oaks, Greystone, Tregaron, and the Homestead. For the purpose of capturing the broadest history of this neighborhood and its fluctuating boundaries throughout history, we have also included images of estates surrounding Cleveland Park in the neighborhoods of Van Ness, Mclean Gardens, Woodley Park, and the National Cathedral close, such as Peirce Mill, Friendship estate, and the Cloverdale estate.

By the 1920s, Cleveland Park had taken the shape that is still seen today. Most of the streets were in place and the majority of lots on which houses, apartments, and commercial structures were to be built were already well defined and laid out in plans. This was not true, however, for the stretch of Wisconsin Avenue north of Woodley Road, which did not develop a commercial character until the Friendship estate was razed in 1949. This shifted the focus of development towards Connecticut Avenue, which was paved past the Klingle Valley in 1891 and serviced with a trolley in 1892, despite the fact that the early origins of Cleveland Park had their start along the far-older Wisconsin Avenue.

For many years Newark Street only stretched from Wisconsin Avenue to a point just past 34th Street, and as recently as 1906, Newark Street was still incomplete. The portion between 33rd Street and Ashland Terrace was the last built, so that in order to traverse from Connecticut Avenue to Wisconsin Avenue one was required to detour to Highland Terrace. The 1920s building boom in Cleveland Park took off largely as a by-product of infrastructure improvements that had been made by the Chevy Chase Land Co., owned by Sen. Frances G. Newlands. His company built the Calvert Street Bridge in Woodley Park, allowing trolley service to extend west and north of Rock Creek Park. Senator Newlands also bought up land along the path of the expanding Connecticut Avenue starting in the 1880s and ensured that it was built all the way to Chevy Chase, Maryland.

The establishment of the National Bureau of Standards near the intersection of Connecticut Avenue and Tilden Street in 1901 provided an easy walk to work for approximately 500

scientists and statisticians, which added to the many prominent government employees who were already moving into the area. With easy transportation to the rest of the city and the development of new sources of employment and social infrastructure, the area was the logical location for development such as the Holy Cross College in 1907, the John Eaton School in 1911, Fire Engine 28 in 1916, and the beginning of construction of the National Cathedral in 1907.

With the area rapidly being developed with large single-family homes in the 1920s, the building boom of the commercial strip along Connecticut Avenue was inevitable. This included the Park and Shop in 1931 and the Up Town Theater in 1935. The apartment buildings of Cleveland Park were also largely built in the 1920s, from the Parkway Apartments at Macomb and Connecticut in 1921 to the Broadmoor at Quebec and Connecticut Avenue in 1929, and finally the Quebec Apartments in 1945, designed by Donald Drayer.

Cleveland Park changed character again in the 1940s as many of the old estates began to change from private residences to public and private intuitions. Beauvoir was donated to the National Cathedral in 1922 and Red Tops, President Grover Cleveland's home, had been razed in 1928. During World War II, the Friendship estate was sold, razed, and redeveloped as temporary dormitory housing during the war, and it later was redeveloped as the McLean Gardens neighborhood. The Nourse mansion was sold to the Sidwell Friends School in 1956 after it had rented the property since the 1940s, while the Woodley estate was also transformed when it was sold in 1950 to the Maret School.

Twin Oaks became the residence of the Taiwanese ambassador in 1937 when Alexander Graham Bell's sister-in-law Grace Bell leased the family property for the first time since 1888. Tregaron ceased to be a single-family home in 1958 and faced hard times as its owners debated tearing down the estate and building apartment towers. That house was not saved until 1979 when it was purchased by the Washington International School.

Of all of the challenges to Cleveland Park's character, the 1980s proposition to tear down the Park and Shop to make way for a high-rise office building galvanized the community to ensure its future and preserve aspects of its past. An area comprised of approximately 1,000 buildings was designated a National Register of Historic Places Historic District on April 27, 1987.

This early view of the rural hill located behind Pierce Mill (to the right) is today the site of many of Cleveland Park's fashionable addresses. (HSW.)

One

EARLY ORIGINS
AND ESTATES

Since the early 1800s, grand estates have graced Cleveland Park and have been home to United States presidents, notable politicians, as well as some of Washington's—and the nation's—elite residents. Cleveland Park's famed estates have served as elegant homes for many historic figures, from President Grover Cleveland to Alexander Graham Bell.

Looking to escape the heat of the low lands in and around the port of Georgetown and speculating on the future development of a new national capital in the area, Gen. Uriah Forrest, formerly a mayor of Georgetown, and Col. Benjamin Stoddert purchased 998 acres of land from George Beall. It was a portion of a larger tract dating back to 1720 and coined the "Rock of Dunbarton." In 1794, Uriah Forrest bought Stoddert's portion of what they had named "Pretty Prospects" and renamed it Rosedale.

At the time, there were few structures in the area and the nation's capitol was still largely in the planning stages. One of the earliest homes located in what is now Cleveland Park was a house known as "Friendship," also known as the Villa, which by some accounts dates back to 1695. The Stoddert family was recorded there as early as 1711, and much later, it was rented to Georgetown College as a summer retreat. In 1898, it was enlarged and re-introduced with the name "Friendship" by John R. McLean and his wife Evelyn, an owner of the infamous Hope diamond.

Probably the most notable of the early estates encompassing a large portion of Cleveland Park was "Woodley"—a Georgian manor house estate that stood of 18 acres of land surrounded by impressive oak and chestnut trees. Woodley—from which Woodley Park's name derives—was originally part of a much larger tract of land owned by George Beall and Gen. Uriah Forrest in the 1790s. Forrest would later sell part of the land to his brother-in-law, Philip Barton Key, who built Woodley between 1800 and 1804. Key's nephew, Francis Scott Key, spent considerable time at the estate.

In 1817, Joseph Nourse established prominence in the area when he purchased the land on which the Highlands was to be built at 3825 Wisconsin Avenue and gave the house to his son, Maj. Charles Nourse, as a wedding gift in 1827. Isaac Peirce renovated and rebuilt a flour mill in Rock Creek Park in the 1820s, one of several that operated among the riverbed in what was then a rural portion of the city. John Adlum owned a portion of land called the Vineyard, located near today's Van Ness/UDC area, in the 1820s and enjoyed cultivating over 22 varieties of grapes on his estate. The Klingle mansion was built in 1823 by stonemason Joshua Peirce, son of mill owner Isaac Peirce, while the estate known as Beauvoir was built in 1858 by Dr. Samuel C. Busey on today's National Cathedral close.

After winning the election in 1885, President Grover Cleveland bought George F. Green's Forrest Hill estate and remodeled it, moving in the following summer. Many prominent families would follow, and several renamed the emerging community in his honor. They included Gardiner Greene Hubbard and his wife Gertrude, who built Twin Oaks in 1888. While many of the early estates were subsequently razed, others survived, despite a reduction in their vast lawns and landholdings, and can be spotted among the single-family homes that began to be built regularly in the 1890s.

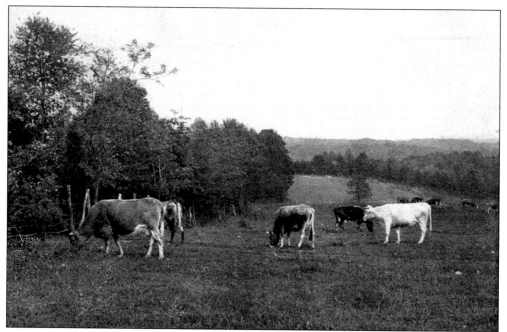

Scenes like this were typical of the environment in and around Cleveland Park at the turn of the 20th century. To this day, the hill behind the old Holy Cross College is still called "cow hill," although deer are the only animals witnessed grazing there today. (MLK.)

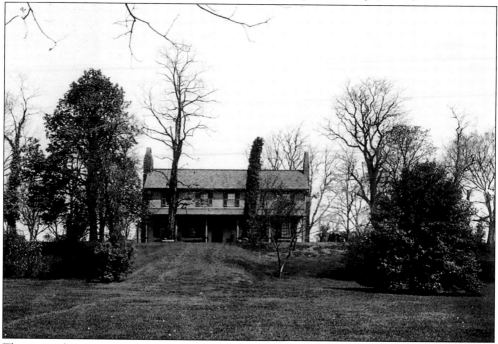

The estate known as Rosedale was once owned by Gen. Uriah Forrest and his two business partners, Col. Benjamin Stoddert and Col. William Deakins Jr., when they purchased approximately 1,000 acres of land in 1794 and named it "Pretty Prospects." It was then part of Montgomery County, Maryland. (HSW.)

This view of the woods in northwest Washington was taken in 1913. The area continued to be rather rural in nature despite some of the early estates having been sold and divided for the development of subdivisions. One early resident was quoted as saying, "One may wander day after day in new walks all through these woods to the northwest and west of the city. One never need take the same walk twice, for there is an endless variety of foot-paths, each with its own vistas of wood land beauty." (MLK.)

In 1794, Uriah Forrest moved from Georgetown with his wife Rebecca Plater into the expanded Rosedale estate to escape the heat and pollution of what was then an industrial port town. The section of Rosedale seen here dates back to 1746, when the land belonged to the Beall family of Georgetown. (MLK.)

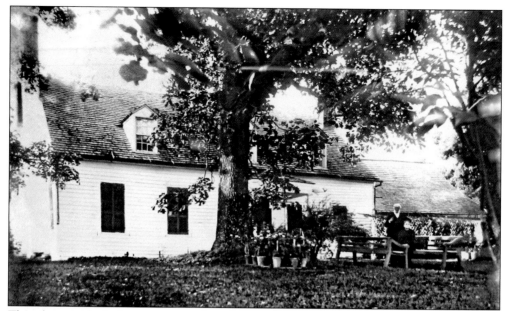

This photograph depicts an unnamed yet longtime resident of Rosedale. Gen. Uriah Forrest, formerly a mayor of Georgetown, and Col. Benjamin Stoddert had originally purchased a 998-acre tract of land from George Beall. It was a portion of a larger tract of land dating back to 1720 called the Rock of Dunbarton. In 1794, Uriah Forrest bought Stoddert's portion of what they had named "Pretty Prospects" and renamed it Rosedale. (LOC.)

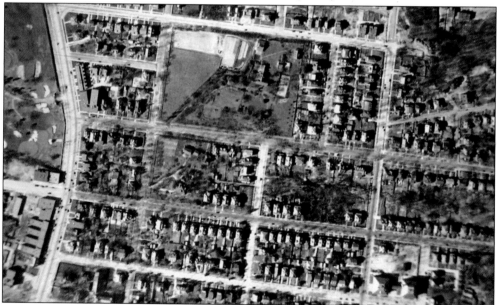

Seen here in 1927 are two of Cleveland Park's summer homes, Rosedale and Oak View (also known as Red Tops). The former is the oldest surviving building in the neighborhood and the latter the home of Grover Cleveland, the neighborhood's namesake. Grover Cleveland renovated Oak View, formerly Forrest Hill, in 1886 and used it as a summer White House until he sold the property to Sen. Frances G. Newlands in 1890. The house stood facing Macomb Street until it was razed in 1928. (NA.)

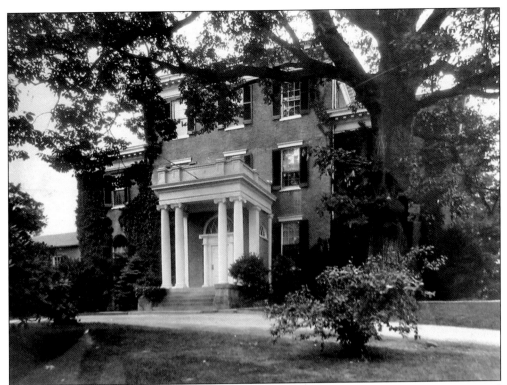

The construction date of Woodley, located at 3000 Cathedral Avenue, is believed to be around 1800, but the first documented record of occupation dates to 1804 when the fourth of child of Philip Barton and Ann Key was born there. Philip Barton Key, uncle of Francis Scott Key, built the impressive house that has said to have been the summer home of four U.S. presidents—Martin Van Buren, John Tyler, James Buchanan, and Grover Cleveland. (LOC.)

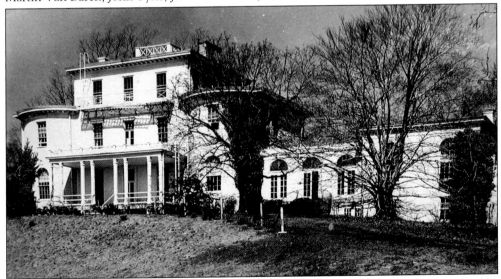

This photograph of the south side of Woodley was taken in April 1958, when it was owned by the Maret School. Once located at 2118 Kalorama Road, the institution purchased the former mansion in June 1950 and, following renovations, moved into the building in 1952. (LOC.)

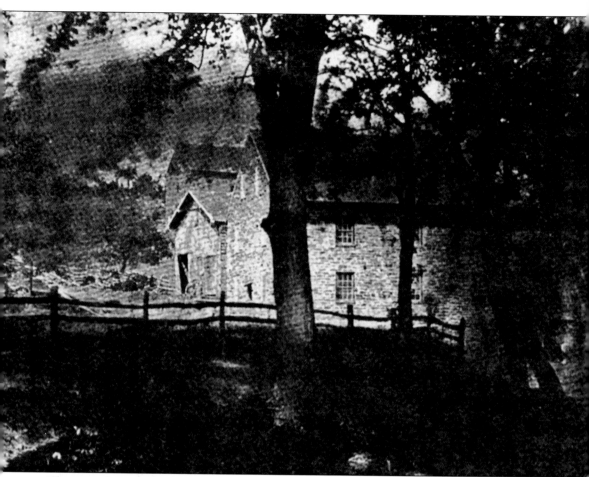

This rare photograph of Peirce Mill was taken in 1855 by Titian Ramsey Peale. Of the three buildings visible, only the mill (far right) and the barn (now known as the Art Barn, at left) remain. Isaac Peirce first purchased 150 acres in 1794, including a grist mill near the location of Peirce Mill, and kept buying property until 1800 when he owned all of the land along Rock Creek from the National Zoo to Chevy Chase, save the land surrounding the Blagden Mill. Peirce did not build Peirce Mill until the 1820s, with the date 1829 inscribed into the building along with BIP, possibly meaning "built by Isaac Peirce." (LOC.)

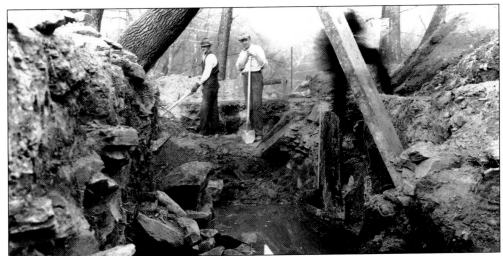

Two men repair the water race during the 1934–1936 restoration of Peirce Mill. The mill has had three periods of continuous operation, with the first lasting from the 1820s when Isaac Peirce replaced a pre-existing mill with his own, to 1897 when a break in the main shaft and the shift in milling to the Georgetown's waterfront ended the mill's first run. The government restored the mill in 1934 under the Works Progress Administration (WPA), which allowed it to operate as a government mill, grinding flower for the White House and government cafeterias until 1957. The last period of operation lasted from 1985 to 1993 when the Park Service ran the mill as working exhibit of 19th-century technology. Deterioration of the water wheel led to its closure. (Photograph by Albert S. Burns for HABS.) (LOC.)

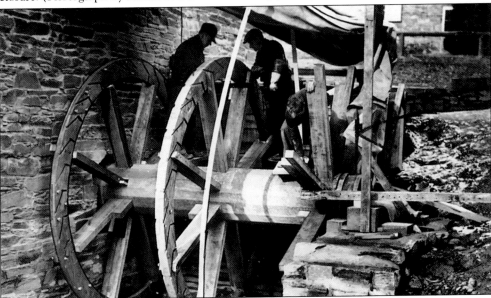

These men were pictured on the waterwheel at Peirce Mill in 1937. After Harold Ickes, Secretary of the Interior, decided in 1934 to restore Peirce Mill as part of the WPA's efforts to alleviate Depression-era unemployment, millwrights set to repairing the water wheel, which had been inoperable since a mechanical failure in 1897. Milling again commenced on December 1, 1936. It remained operable until 1957, when it closed due to a lack of skilled millwrights and stone dressers, as well as reduced water levels in Rock Creek. (HSW.)

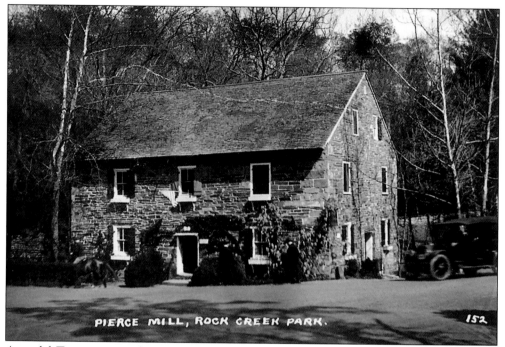

PIERCE MILL, ROCK CREEK PARK. 152

A model-T car is pictured at Peirce Mill in the 1930s. The National Park Service rented out the mill to various tenants between 1904 and 1935 for the purpose of housing tearooms. The conversion from mill to restaurant required the removal of the milling machinery from the interior of the mill, destroying forever the original milling machinery from the 1820s. (HSW.)

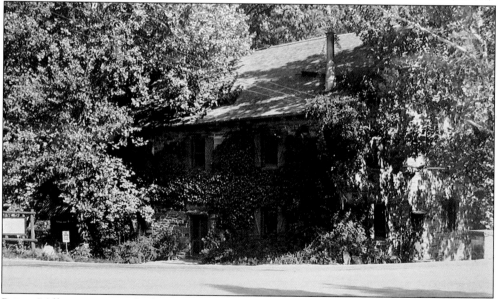

Peirce Mill was extensively documented by the Historic American Buildings Survey (HABS) in 1935. This photograph shows the state of near-abandonment that occurred as a result of the Depression. Incidentally, the spelling of the Peirce family name has changed over the years. The initial spelling was Pearce, but the signature on Isaac's will changed it to "Peirce." Family members finally changed the spelling to Pierce. (LOC.)

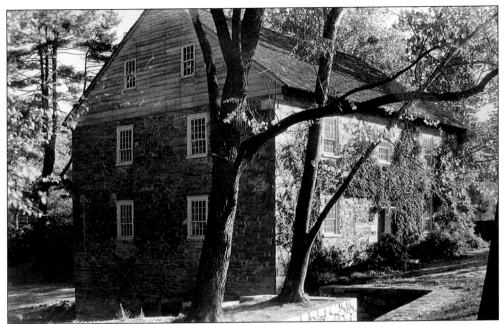

During the 1934–1936 restoration of Peirce Mill, the water race was re-dug, allowing water to power the mill via a rebuilt water wheel. In the 1820s, when Isaac Peirce replaced the nearby preexisting mill, he also replaced the undershoot wheel, added two runner wheels, and made further technological improvements inside the mill. Later, in 1840, Isaac and his son Abner C. replaced the undershoot wheel with an overshoot. The overshoot wheel was again replaced in 1897 with a metal overshoot turbine. The mill is pictured here on October 7, 1935. (LOC.)

While being used as a tearoom during the 1930s, the broken mill wheel was removed altogether and this screened-in porch was built over the location. The mill's race had been both filled in and covered over. (Photograph by Albert S. Burns, HABS.) (LOC.)

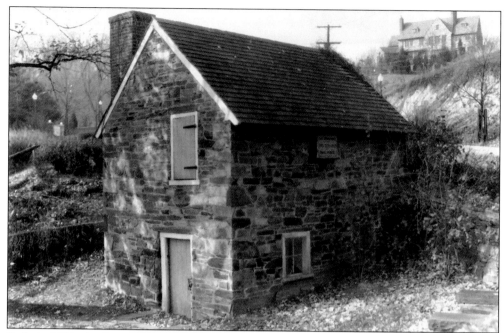

Built in 1801, the Spring House predates Peirce Mill by as many as 28 years. The Peirce family engaged in many different businesses, such as horticulture, viticulture, and animal husbandry. One function of the spring house was to keep dairy products cool during the summer by running cold spring water through a trough that held containers of milk and butter. Notice the fine house in the rear of this photograph, which was taken in 1935. (Photograph by John O. Brostrup, HABS.) (LOC.)

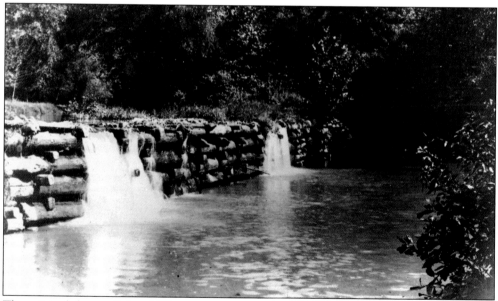

The original dam at Peirce Mill was not stone and cement as it is today, but was originally composed of large logs. This view predates the construction of East Beach Drive in the 1920s, a time when swimming at Peirce Mill was still very popular. (Photograph by E.A. Shuster Jr., HABS.) (LOC.)

The Carriage House, now known as the Art Barn, was located at the intersection of Peirce's Mill Road and West Beach Drive, until West Beach Drive was removed in 1954. (Photograph by John O. Brostrup, HABS.) (LOC.)

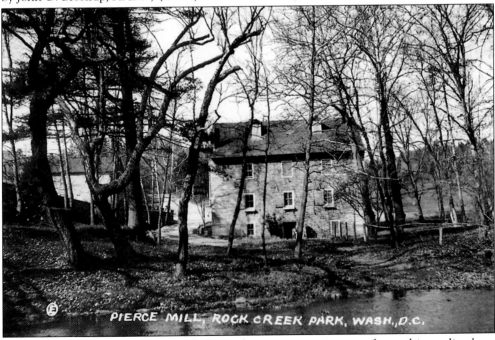

This early photograph of Peirce Mill shows the one-time existence of a road immediately to the south of the mill, as well as the old contours of the river before the addition of the stone retaining wall. The lack of a water wheel or race outlet dates this photograph sometime between 1897 and 1925, by which time the large stone barn at far left was torn down. (HSW.)

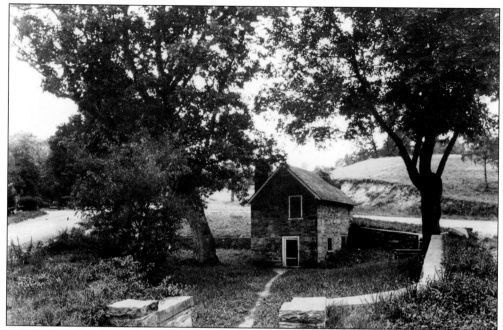

Peirce's Mill Road is pictured here with the Spring House and grazing land to the north. Beginning in the 1920s, Peirce's Mill Road was known as Quincy Street, and later, when Tilden Street was widened and straightened, the Spring House was placed on an island in the middle of the road. (LOC.)

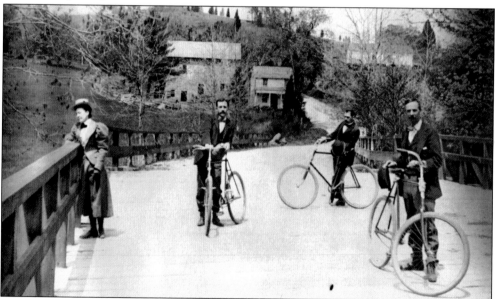

These four Washingtonians on the bridge near Pierce Mill were photographed in the 1890s. In the distance is the small stone house known as Cloverdale, the family house that Isaac Peirce built after acquiring the land in 1794. Originally built of hand-hewn oak, the family house was rebuilt in 1874 by Isaac's grandson Peirce Shoemaker. After the death of Louis Peirce Shoemaker, Isaac Peirce's great-great-grandson, the house passed out of the family and was bought in 1928 by E.S. Newman. (LOC.)

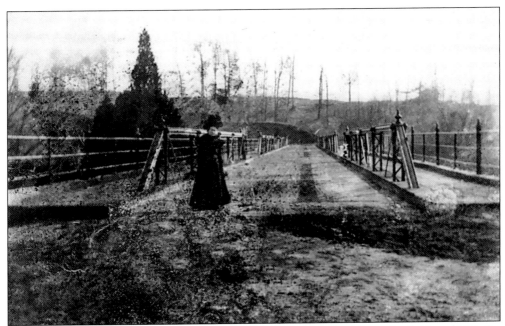

The rural nature of the area in the 1890s is apparent in the view from this bridge, which fits the description of the first Connecticut Avenue bridge over the Klingle Valley. This bridge was built by the Edgemore Bridge Company for the Rock Creek Railway Company in 1891, the same year Connecticut Avenue was extended beyond the Calvert Street Bridge. Records show the old bridge to be 497 feet long, 35 feet wide, and 50 feet off the valley floor. It was built at a cost of $35,000. (HSW.)

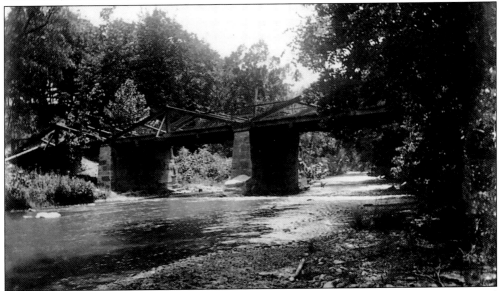

Known today as the Porter Street Bridge, this photograph was taken looking upstream around the turn of the 20th century, when it was called the Klingle Road Bridge. The first bridge to span this location was built in 1886. During the 1940s three different bridges were built, each larger than the next, to accommodate increased car and bus traffic. The final bridge was built in 1947. (HSW.)

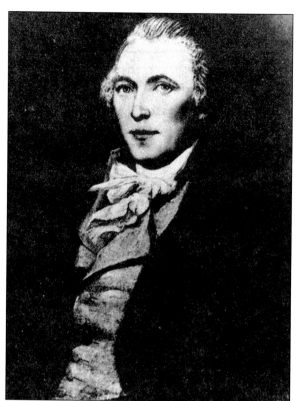

Born April 29, 1759, John Adlum owned a portion of land called the Vineyard located near what is now the Van Ness UDC area. Originally from York, Pennsylvania, John Adlum was a surveyor, farmer, judge, and soldier. He served in the Revolutionary War as a major in John Adams Provisional Army and eventually as a brigadier-general in the Pennsylvania militia. At the age of 54, Adlum married Margaret K. Adlum, his first cousin. Turning his full attention to viticulture at the Vineyard after 1836, Adlum cultivated 22 varieties of grapes and produced the variety used to this day in wine-making called Catawba, which he nicknamed "Tokay." He died March 1, 1836, and was buried at an unknown location somewhere on the Vineyard. (LOC.)

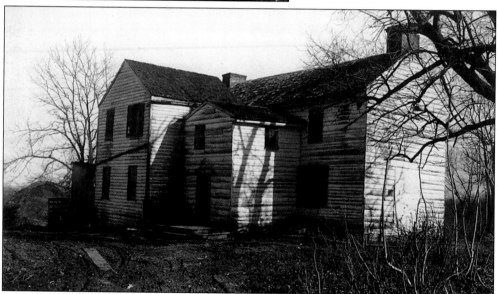

Adlum's estate, known as the Vineyard, was photographed in 1906. The house is reputed to have stood at one of two locations, with surviving family members placing it directly at the intersection of 34th Street, Tilden Street, and Springland Lane. Other accounts point to the southwest corner of Tilden and Connecticut Avenue, where the Tilden Gardens Cooperative now stands. The estate was razed in 1911 as the National Bureau of Standards expanded and Tilden Street was extended. (Photograph by C.M. Marsfield.) (HSW.)

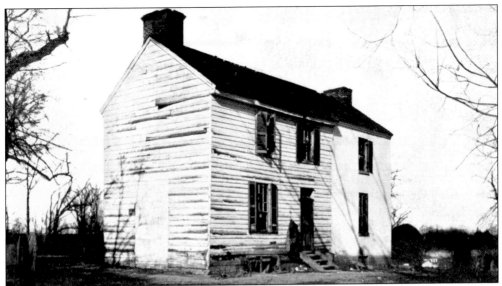

The Vineyard was a 230-acre parcel of land consisting of four separate purchases made by John Adlum between 1816 and 1819. The first was a 45-acre portion of the "Addition to the Rock of Dunbarton," purchased on December 4, 1816 from John Heugh. On June 11, 1819 "Part of the Addition to the Rock of Dunbarton," which consisted of 1 acre and 36 perches, was obtained from Joseph Nourse. A final purchase was made from James Dunlop on February 4, 1820 containing two separate parcels, 93 acres from "Part of the Addition to the Rock of Dunbarton" and 80.25 acres and 4 perches from a tract called "Gizor." John Adlum published a book on American wine grape cultivation entitled, *A Memoir on the Cultivation of the Vine in America and the Best Mode of Making Wine.* (LOC.)

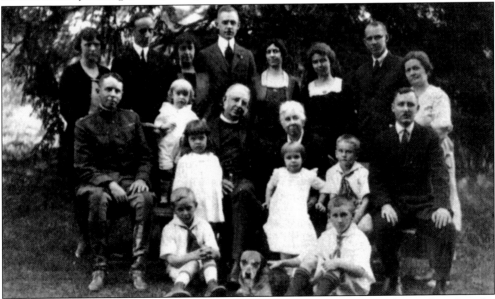

This group of John Aldum's descendants from the Dent and Sterett families gathered at the Springland Farm, in the area now known as Van Ness, on which the National Bureau of Standards was located. Mrs. Adlumia Dent, John Aldum's granddaughter, is seated fourth from the left. (LOC.)

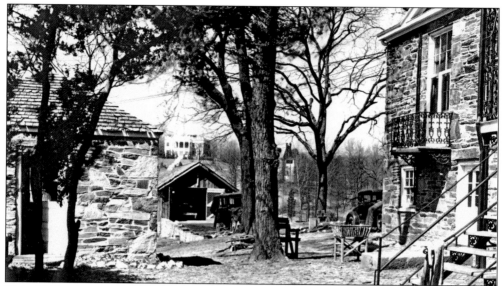

This 1930s photograph by Albert S. Burns shows the Klingle Mansion at far right with a carriage house and slave quarters. The two houses in the distance are on a private road at the end of Quebec Street, today obscured by trees. Klingle mansion was built in 1823 by stone mason Joshua Peirce, son of Isaac Peirce. It was named Linnean Hill after Swedish botanist Karl von Linnaeus, who Joshua admired as a fellow botanist, horticulturalist, and viticulturist. When Joshua Peirce died at his home, the estate went to his adopted son Joshua Peirce Klingle, nephew to his wife Susan A. Coates. In 1890, Linnean Hill was absorbed by the National Park Service as part of Rock Creek Park. (LOC.)

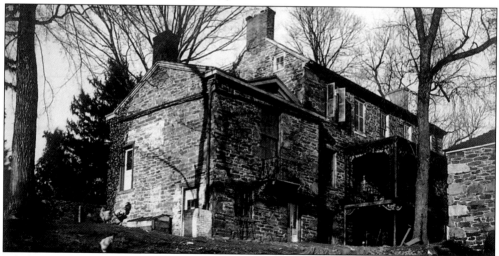

While at the Klingle mansion, Joshua Peirce is credited with establishing the first general nursery in Washington on the 83 acres received from his father Isaac on October 10, 1823, adjoining Rock Creek. The species Joshua Peirce grew around the Klingle Mansion for commercial sale included bald cypress, purple beech, sugar maples, white pines, Norway Spruces, silver maples, silver firs, American arborvitae, American holly, spiraeas, deutzias, purple beaches, American larch, currant, goose, and raspberry. All of these could be obtained via a catalog or by way of a number of local contacts in Philadelphia, Baltimore, Rockville, Annapolis, Leesburg, and Fredericktown, Maryland. (HSW.)

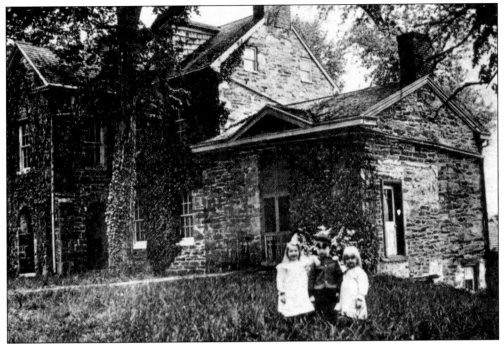

The children pictured here *c.* 1900 were living with their father at their impressive house. He was both a guard at the White House and an animal keeper at the neighboring National Zoo. In 1937, C. Marshal Finnan was living at the Klingle mansion. It was during this time that the house was undergoing restorations. (LOC.)

The Klingle Mansion was photographed on April 11, 1906, at the corner of Klingle Road and Porter Street. Joshua Klingle and his wife Laura moved to Linnean Hill after his uncle-in-law Joshua Pierce's death in 1869. This view of the Klingle Mansion from the south shows an abandoned and since-demolished greenhouse built by Joshua Peirce immediately behind the residence. (MLK.)

The estate of Alfred P. Thom was bought and razed to make room for the National Bureau of Standards complex. It was photographed on December 14, 1936 and was located immediately northeast of the intersection of Reno Road and Van Ness Street. Alfred. P. Thom owned over 12 acres extending from what is now Yuma Street to Van Ness Street, which roughly follows the path of old Peirce's Mill Road. His house was accessed via a private driveway. (MLK.)

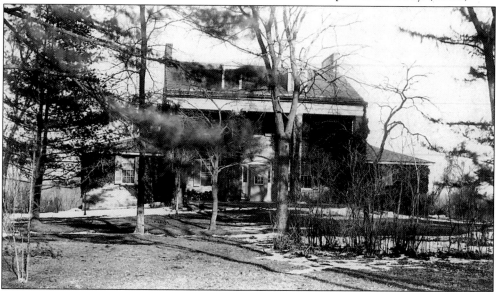

In 1817 Joseph Nourse purchased the land on which the Highlands was to be built at 3825 Wisconsin Avenue. He gave the house to his son Maj. Charles Nourse as a wedding gift at the time of his marriage to Rebecca Wistar in 1827. The name Highlands comes from Rebecca's childhood home in Philadelphia. Its distinctive four columns supporting the roof were added in 1840 when a second floor was added. Joseph Nourse was born in London in 1754, immigrated to Virginia in 1769, and joined the army in 1776. Appointed Registrar of the Treasury by George Washington in 1789, he was fired by Andrew Jackson 1829 for nepotism. (HSW.)

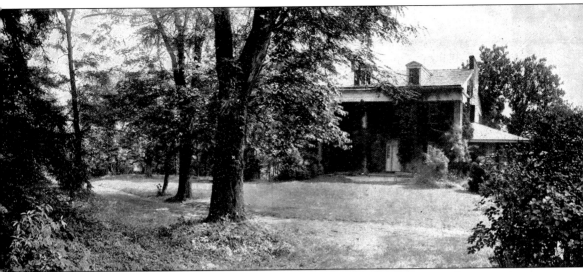

This image of the Highlands appeared in a 1918 advertisement listing it as an "opportunity to restore a famous old Colonial estate . . . of unusual historical interest." By that time, the estate had fallen into disrepair. The house included 20 acres of land and was said to be adjacent to the homes of prominent people, the Episcopal Cathedral, the United States Bureau of Standards, and American University. Wonderful trees and shrubbery were also promoted as selling points. The wisteria growing in the rear was reportedly imported directly from Japan by Mrs. Nourse's father, while the boxwoods were a gift from Thomas Jefferson's garden at Monticello. Its price in 1918 was not listed. (Authors.)

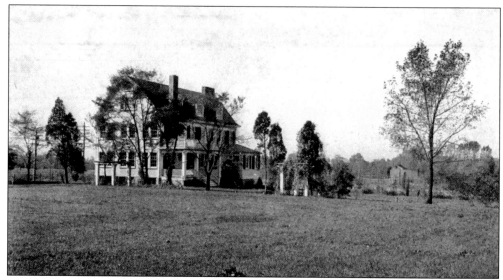

Thomas Watson Sidwell (1858–1936) and his wife Frances Haldeman bought the house he called "The Country Club" at 3901 Wisconsin Avenue in 1911. It was an attempt to expand his Friends Select School, then located at 1819 I Street, N.W. The Friends Select School changed its name to the Sidwell Friends School in 1934. It had started in 1883 with 11 students in attendance on its first day. "The Country Club" was located north of the Highlands and was razed in the 1960s after years of decay. (MLK.)

After the death of Charles J. Nourse, Mrs. Nourse and her father continued to live at The Highlands. The Nourse family retained ownership of the Highlands until 1920 when Adm. Cary T. Grayson, physician to President Woodrow Wilson, bought the estate and bred race horses. The Sidwell Friends School rented the estate in the 1940s and 1950s. Allen Dulles, director of the Central Intelligence Agency, purchased the house and sold it to the Sidwell School in 1954. It is pictured here on April 15, 1951. (HSW.)

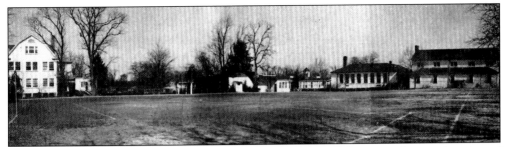

Thomas Sidwell himself built the second building at the new Wisconsin Avenue location of his Friends Select School (then known as the Suburban School) in 1923 for the purpose of holding school dances and other social gatherings. The Sidwell Friends School continued to buy land along Wisconsin Avenue, adding 10 acres on the west side in 1946, which was bought from brewer Christian Heurich. This land was sold in 1954 in order to finance the purchase of the Highlands estate, owned by Adm. Cary T. Grayson. The sale consolidated the school on the east side of Wisconsin Avenue. (Photograph courtesy *Friends Alumni Bulletin* May, 1950) (MLK.)

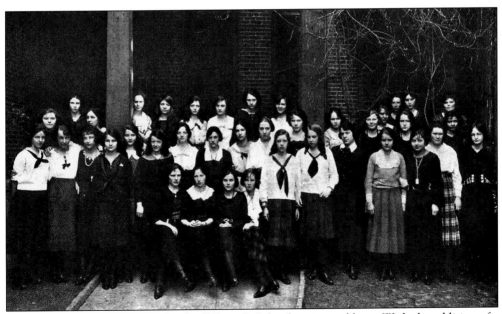

The 1921–1922 girl's chorus of Sidwell Friends School is pictured here. With the addition of a kindergarten in 1925, the Friends Select School became the first school in Washington to offer a full kindergarten-through-twelfth-grade education. (MLK.)

What is today known as the Hurst Recreation Center (located behind Sidwell Friends School) was originally servants' quarters built in the 1860s by James Nourse, son of Joseph Nourse. The Nourse family later left the premises in a will to the Brown family, their African-American servants for many decades. (Authors.)

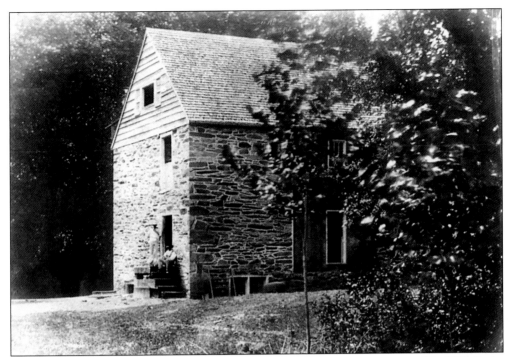

Blagden's Mill in Rock Creek Park is pictured here c. 1860, in an image created by T.R. Peale. This was one of many mills located along the riverbed at a time when rushing waters supplied ample power for multiple operations. (HSW.)

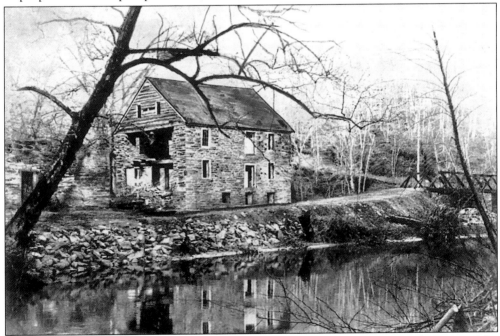

Blagden's Mill was named for Thomas Blagden, who had sold his large rolling farm east of the river in the early 1850s to the city government as the site of St. Elizabeth's Hospital for the Insane. (HSW.)

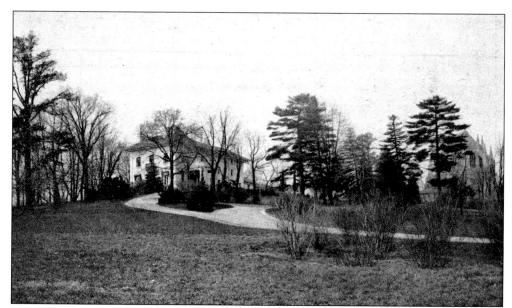

The Italianate mansion known as both Belvoir and Beauvoir (meaning beautiful view in French) was built as Dr. Samuel C. Busey's summer home in 1858. With Dr. Busey's death in 1901, the property passed to Nevada senator William Sharon. The last private owners of the estate, however, were Mr. and Mrs. J. Townsend Russell, the Residentiary Canon of Washington, who gave the estate to the Protestant Episcopal Cathedral Foundation in 1922. At that time, the property included 13 acres and was valued at $400,000. Beauvoir was then used as an elementary school but was ultimately razed in the early 1960s to make room for a school by the same name. (MLK.)

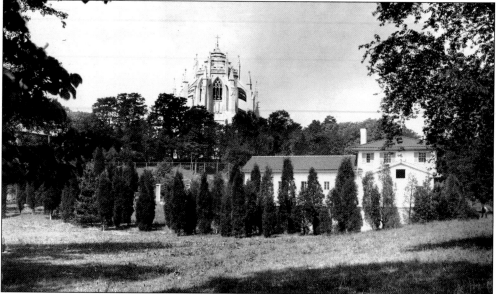

This unique view of the National Cathedral Apse was taken from the front lawn of the Beauvoir estate just off Woodley Road. The only remaining structures from the original Beauvoir estate are the coach house, seen here at right, and the gateposts at the northwest corner of Woodley Road and 34th Street. (NCA.)

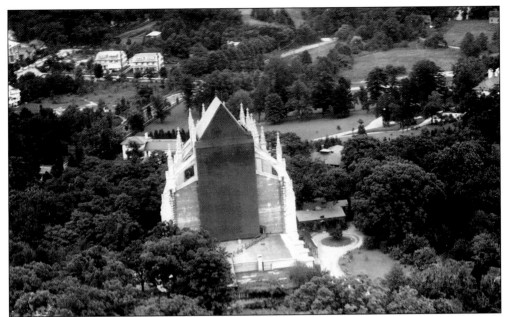

At the extreme top right of this image is one of the earliest farm buildings in Cleveland Park, just southwest of the intersection of Woodley Road and 34th Street. At the extreme top left is the first section of the John Eaton School. The entrance to Twin Oaks can be seen between the two. The house at the far right was the Beauvoir estate, while the small buildings to the right of the Cathedral served as their administrative offices. (NCA.)

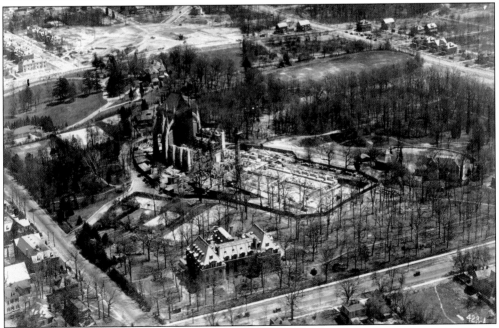

The Cathedral close is shown here in 1923 after the inclusion of the Beauvoir estate, directly behind the partially completed Cathedral. Residential development of 34th Street, Garfield Street, and Cleveland Avenue remained incomplete, while Victorian homes and vacant lots lined Wisconsin Avenue and Woodley Road, as seen at the bottom of this photograph. (NCA.)

This sketch of Forrest Hill, the home of George Forrest Green, grandson of Uriah Forrest, shows the dwelling prior to the extensive renovations made by President Grover Cleveland in 1886. The house is said to be built with local fieldstones found on-site in 1865. (HSW.)

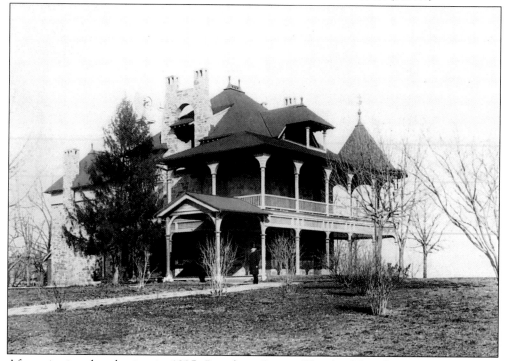

After winning the election in 1885, President Grover Cleveland bought George F. Green's Forrest Hill for $21,500. In order to avoid unwanted attention, he bought it through a middleman named Albert A. Wilson on May 27, 1886. However, when Wilson transferred the title to President Cleveland, the sale became public knowledge and local residents named the area Cleveland Park in his honor. Cleveland renamed the house Oak View and hired architect W.M. Poindexter to remodel the house in a Victorian manner, encasing the house in porches, adding a cupola, and painting the roof red. A newspaper article about the house at the time referred to it as Red Top, a popular name that stuck. (HSW.)

Artist Fudge depicted Grover Cleveland in this portrait completed between 1890 and 1899. Cleveland sold his house Oak View (or Red Top) and its surrounding land to the real-estate mogul Frances G. Newlands on April 23, 1890 for an astounding $135,000. Newlands quickly created a subdivision named Oak View. (LOC.)

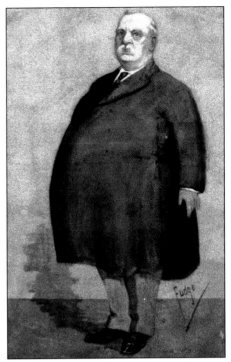

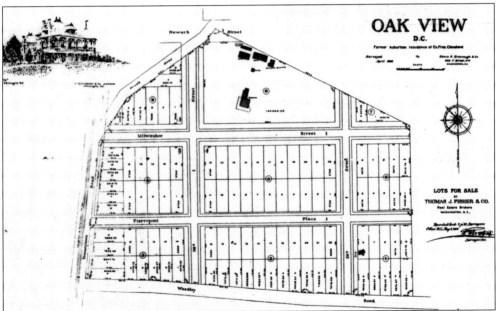

This plat map of the proposed subdivision coined Oak View was marketed by the Thomas J. Fisher Company in April 1890. The land offered to prospective homeowners was what had surrounded Red Top, which was still standing at the time. It is seen at the top of the development, facing what is today Macomb Street. The newly plotted land stretched south to Woodley Road on the eastern side of Wisconsin Avenue (old Tennleytown Road) and included the 3400 to 3600 blocks of Macomb and Lowell Streets (old Milwaukee Street and Pierrepont Place). (CPHS.)

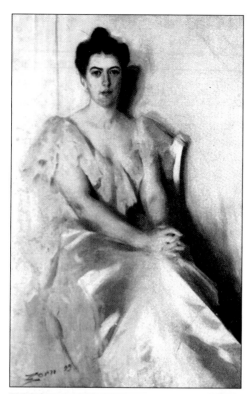

Born in Buffalo, New York, Frances Folsom (1864–1947) married Grover Cleveland in 1886 at the White House and lived with him at Oak View, and later at Woodley. The block of 35th Street between Macomb and Newark Streets was for a time unofficially renamed Folsom Place in her honor. (MLK.)

This 1922 aerial photograph, looking north over the Cathedral, clearly shows Oak View in the background facing Macomb Street, just south of 35th Street. The Rosedale estate is also visible. It is interesting to note that both Rosedale and Oak View were built before and at a slight angle to the street pattern so that they faced more southwesterly than the surrounding homes. (NCA.)

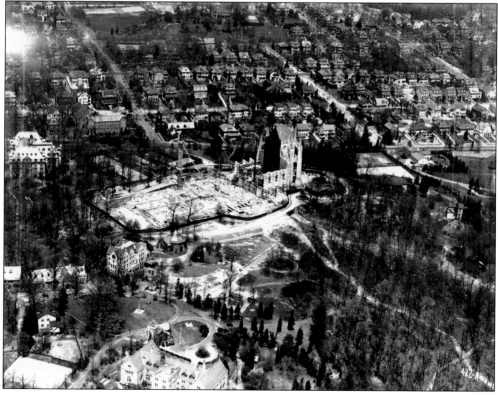

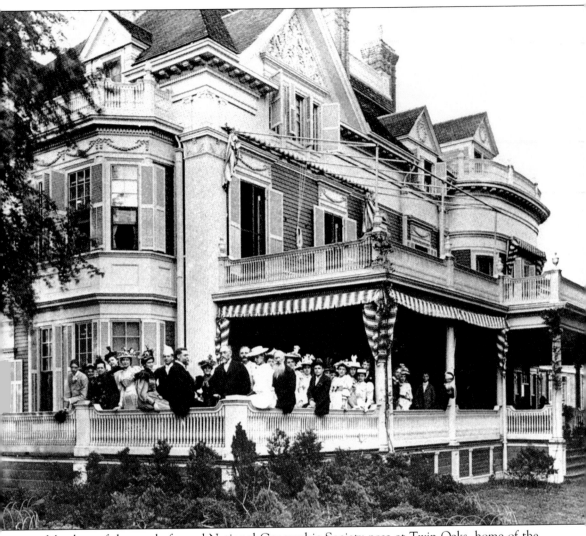

Members of the newly formed National Geographic Society pose at Twin Oaks, home of the society's founder Gardiner Greene Hubbard. He purchased the 50 acres of land on which the house was built in 1886 and commissioned Frances Richmond Allen to build Twin Oaks in 1888 as his summer residence. At that time, his home was located at Dupont Circle. Earlier, the land had belonged to Philip Barton Key, the first owner of Woodley and uncle to Francis Scott Key. (LOC.)

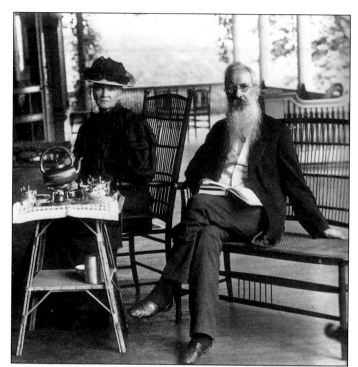

Gardiner Greene Hubbard and his wife Gertrude Hubbard are seen here on the porch of Twin Oaks, which they enjoyed as a summer house in order to escape the heat of urban Washington. Hubbard was the first president of the National Geographic Society and served from 1888 to 1897. Now the property of the Taipei Economic and Cultural Representative Office, the house once served as the residence of the ambassador of the Republic of China for many years. (Photograph by Peter Bisset, © National Geographic Society.)

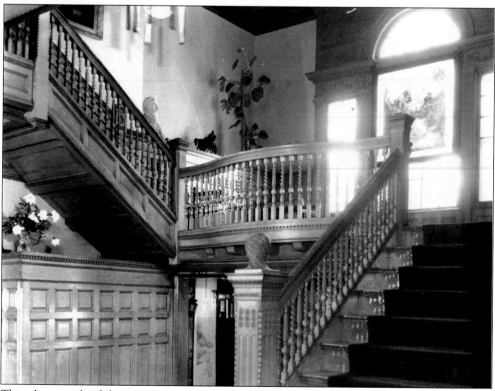

This photograph of the interior staircase and entry hall of Twin Oaks at 3225 Woodley Road was published it the *Evening Star* on July 10, 1945. (MLK.)

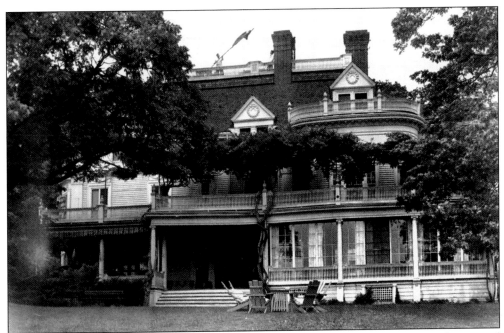

A front view of the impressive house known as Twin Oaks was taken while it was being used as the residence for the ambassador of the Republic of China. (*Evening Star* photograph, July 10, 1945.) (MLK.)

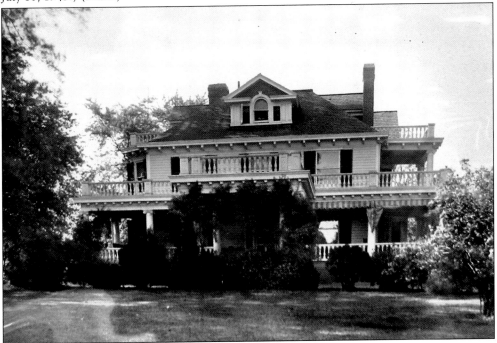

This unusual view shows Twin Oaks from Macomb Street. Until 1909, when Twin Oaks was divided and the southern portion sold to James Parmelee (builder of The Causeway), the estate had a single undivided lawn that stretched from Hubbard Place (33rd Street today) to a steep hill near Klingle Road, on which sheep and cows grazed.(LOC.)

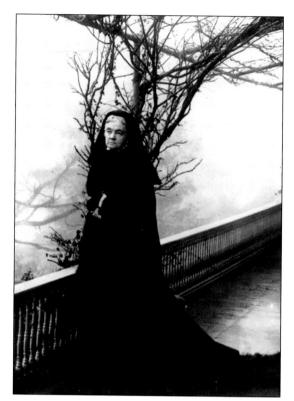

Gertrude McCurdy Hubbard is seen here on the second-story porch at Twin Oaks after her husband Gardiner Green Hubbard died in 1897. Gertrude survived her husband by 12 years, after which the Twin Oaks property was divided. The eastern 20-acre portion went to Alexander Graham Bell, who had married the Hubbards' daughter Mabel after serving as her teacher for four years. Upon Mabel's death, the estate was inherited by Charles J. Bell (unrelated to Alexander), and his wife Grace Hubbard Bell. They lived in Twin Oaks until 1937, when they leased the property to the Chinese government. Alexander and Mabel sold the easterly portion of the estate two years after inheriting it in 1911 to James and Alice Parmelee, who built The Causeway, which is now known as Tregaron. (LOC.)

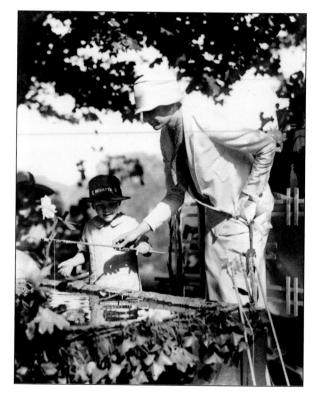

Madame Luciano Mascia is seen here helping a child at an artificial fishpond on the grounds of Twin Oaks. The photograph was snapped at a garden party held at Twin Oaks, the estate of Grace Hubbard Bell, on May 21, 1926. (LOC.)

Two

The Beginning
of Development

While it seems almost inevitable in retrospect, the large and early summer estates located in Cleveland Park were not able to resist the temptation for subdivision, as several developers purchased large amounts of lands and former estates with the idea of speculating on the need for the city's expansion. An 1888 "Act to Regulate the Subdivision of Land Within the District of Columbia" mandated that newly plotted lots maintain the grid and alphabetic system found within the original boundaries of Washington, which then lay south of Florida Avenue.

Land speculators often worked in stealth transactions to acquire tracts of land. For example, the Chevy Chase Land Company purchased most of the land on either side of the extension of Connecticut Avenue, eventually funding the bridge over Rock Creek Park at Woodley Park to enhance the value of their land value along the new streetcar route. Thomas Waggaman and John Sherman purchased over 400 acres of land in May 1894, north of Woodley Road and between Connecticut Avenue and Wisconsin Avenue in anticipation of this need for suburbanization. Their first plat, coined "Cleveland Park," was ultimately successful, originating along Newark Street from the western portion of Cleveland Park today, and then along the far more developed Wisconsin Avenue.

Along Connecticut Avenue, the Cleveland Park Company built a small lodge at Newark Street to serve as a streetcar waiting area in 1898 and advertised the suburb in a well-known booklet in 1904. Many of the images of emerging houses of the time and their country-like settings are reproduced in this chapter. The lodge was destroyed by fire in 1912 and is today the site of the Cleveland Park Library, which continues to be a central meeting point for community residences.

Not all early housing development was the typical large, single-frame homes built in Cleveland Park in the first two decades of the 20th century, however. One notable exception was the purchase by John McLean of a large tract of land called "The Villa" in 1898 along Wisconsin Avenue. It was transformed into a spectacular summer estate named "Friendship" and utilized most famously by his daughter-in-law Evalyn Walsh McLean, owner of the famous Hope Diamond. Although a few of the former summer estates still exist (albeit reduced in size) among Cleveland Park's rows of more modest housing, Friendship lasted until World War II when it was subdivided into temporary, and eventually permanent, housing for an expanding Washington population.

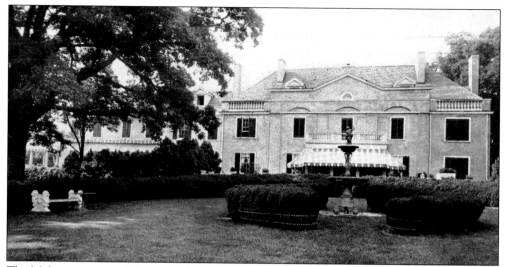

The McLean estate on Wisconsin Avenue, known as "Friendship," once occupied the area now known as McLean Gardens. The age of this tract of land is not clear, but historians believe that as early as 1695 a small house was located here. A deed from 1711 records the grant of a 3,124-acre parcel named Friendship to Col. Thomas Addison and James A. Stoddert. By 1905, a Dr. French was living in a brick house thought to be over 100 years old, which was later obtained by Georgetown College as a theologian's retreat and renamed "The Villa." In 1898, John R. McLean purchased The Villa and the surrounding 60 acres for $250,000 and renamed it "Friendship." His son Edward, along with Edward's famous wife Evalyn Walsh McLean, inherited the estate in 1916. (Authors.)

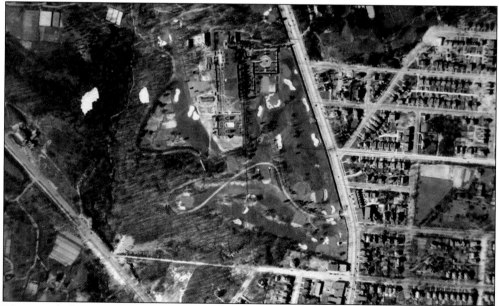

This aerial photograph, taken by the Army Air Corps in 1927, shows the Friendship Estate of Edward Beal and Evalyn Walsh McLean. The road running north to south at a slight angle is Wisconsin Avenue with an uncompleted Newark Street crossing toward the bottom. The Nourse Mansion, Friends Select School, Rosedale estate, and Oak View all appear to the east of Wisconsin Avenue. (NA.)

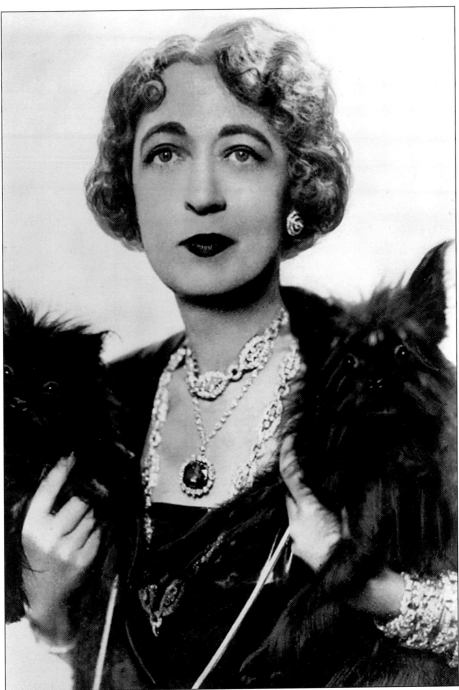

Friendship resident Evalyn Walsh McLean is seen here with her two dogs and the Hope Diamond. Evalyn acquired the diamond from a mysterious gentleman for a price of $114,000 and several other less desirable pieces of jewelry. Upon hearing of her daughter's purchase, her mother T.F. Walsh had this to say of it: "It is a cursed stone and you must send it back . . . your buying of it—a piece of recklessness." The curse apparently caused Walsh much despair during her ownership of the jewel. (HSW.)

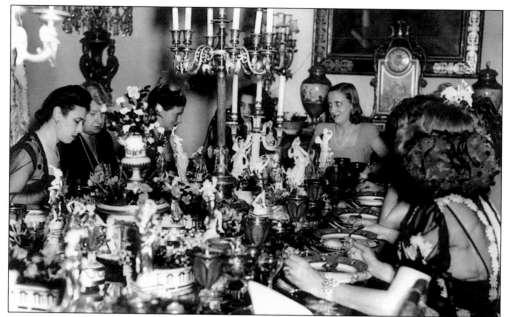

Evalyn Walsh Mclean often entertained lavishly at Friendship, even inviting members of the press to photograph the events. Here guests are seen dining at a party in the early 1940s. Friendship served as the Walsh's summer retreat. The large house at 2200 Massachusetts Avenue, today the Indonesian Embassy, served as their main residence. (HSW.)

This fountain to the east of Friendship was only one small part of the extensive landscaping that covered the estate's 75 acres, which included a large swimming pool and a 9-hole golf course extending from the Sidwell Friends School to Newark Street. The estate also featured a large yellow water tower with large clock and winding staircase that was a familiar landmark to many in the neighborhood. (LOC.)

This picture of Evalyn Walsh Mclean with her three surviving children taken at Friendship includes (from left to right) Edward B. Mclean, Evalyn B. Mclean, and John R. Mclean. Young son Vinson was accidentally killed in 1919 outside the gates of the estate when a passing car hit him. (LOC.)

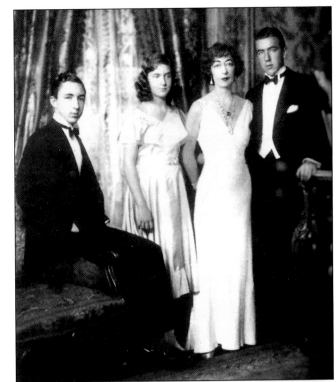

Evalyn Walsh McLean is seen below seated at center with her dinner guests admiring the Hope Diamond in 1942. Her dinner parties were a chance for guests to meet and mingle with others of Washington's elite, including President Harding. As many as 600 people attended Evalyn's dinner parties. (HSW.)

This portrait of Evalyn Walsh McLean's son Vinson was taken shortly before he escaped the protective guise of a servant and dashed into traffic on Wisconsin Avenue in front of the Friendship estate in May 1919, when he was just nine years old. Many blamed the accident on her ownership of the supposedly cursed Hope Diamond. (HSW.)

The gardens at Friendship were immaculately kept. This view looking south from the house towards Newark Street, bordered by two sphinxes, was surrounded by the golf course. A sand trap can be seen in the distance. In addition to the luxurious gardens and grounds, the McLeans kept a large variety of animals on their property, including peacocks, 40 or more dogs, a monkey, goats, a donkey, parrot, llama, and miniature horses. (LOC.)

This heavily doctored image of Vinson McLean was superimposed onto a backdrop image of the Friendship estate in a portrait studio. Vinson's father's fortune stemmed from the *Washington Post* empire, and his mother's wealth stemmed from the Camp Bird gold mine in Colorado started by her father, Irish immigrant John F. Walsh. (HSW.)

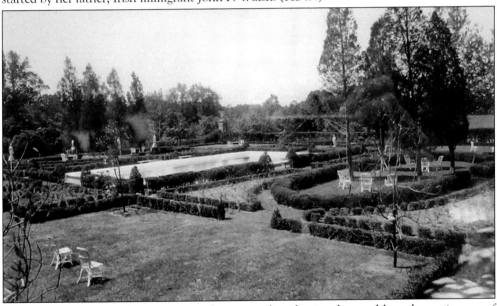

The gardens at Friendship were second to none, but despite the wealth and prominence of Edward and Evalyn, their marriage disintegrated as the reclusive Edward increasingly turned to a debaucherous life of drinking and womanizing, while Evalyn battled drugs and alcohol. Evalyn separated from her husband in 1927 and divorced him in 1931 after obtaining the Friendship estate. She eventually had Edward committed to the Shepard Pratt Institute, an insane asylum in Baltimore, where he died believing he was a French spy. Many believe it was another result of owning the cursed Hope Diamond. (HSW.)

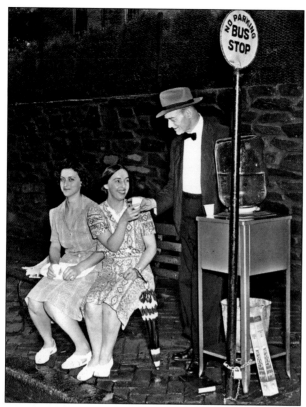

Gustava Grifoni, Mrs. McLean's butler, offers water to Marion (left) and Jeanette Gass at the bus stop outside the Friendship estate. As part of her war effort, Evelyn Walsh Mclean provided benches, paper cups, water coolers, and often her personal staff for the waiting bus riders when this image was captured by a *Washington Star* newspaper photographer on July 26, 1942. (MLK.)

As a staunch supporter of the war effort, Evalyn Walsh McLean sold her Friendship estate on December 31, 1941 to the United States government for $1 million and moved to a house at 3308 R Street in Georgetown, which she also named Friendship. Soon after, the government developed all of the Friendship estate into temporary housing for the massive influxes of wartime government workers. At the time of this photograph, the mansion was being utilized as the office for the construction project shortly before it was razed. (MLK.)

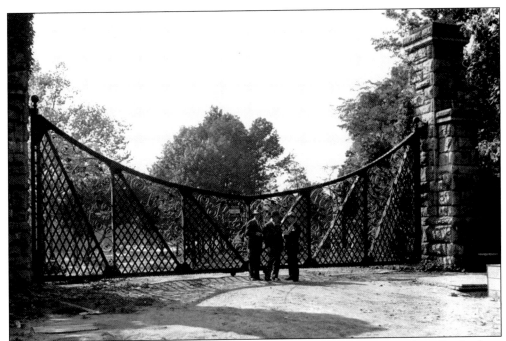

The massive entrance gates at Friendship were so heavy that they required small wheels to enable their graceful swing onto Wisconsin Avenue. Known as the largest wrought-iron gates of any private residence in Washington, government workers are seen here inspecting the gates before their removal in 1942 for scrap metal. (Smithsonian.)

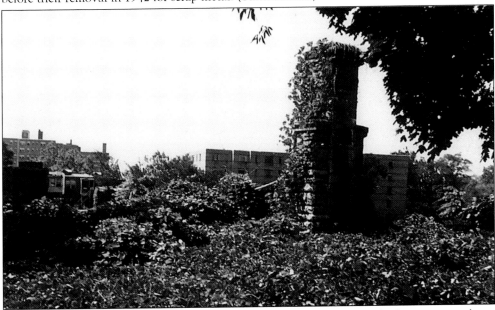

All that remained of the Friendship estate by the end of the war was the large stone column for the old gate when this image was taken on July 30, 1949. A recreated set of gates grace the entrance today. Rents in the newly built dormitories on the site were $8 a week for single rooms, $7 for doubles, apartments for $60 per month (including kitchenettes), $72.50 for one-bedrooms, and $85 dollars a month for two-bedroom units. (HSW.)

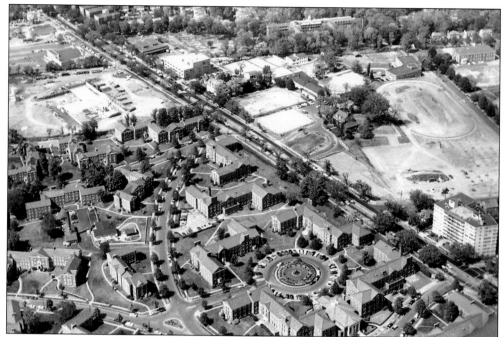

The Defense Housing Corporation was responsible for redeveloping the 75 acres of the Friendship estate into housing for people involved with the war effort. The corporation hired architects Kenneth Franzheim and Alan B. Mills, and the George F. Fuller Co. as builders. The total cost of building the 31 apartment houses and 9 dormitories that housed 3,000 people was $7 million, and in the process the Friendship house was broken up and sold for scrap. Prospective tenants had to meet two requirements for approval: that they were employed directly with wartime work or the military, and that they were not expected to live in Washington for more than a year. (MLK.)

The Homestead, or "La Quinta," at 2700 Macomb has been the home to every Indian ambassador since 1945, when that nation was newly independent. It was built in 1914 and designed by Frederick B. Pyle as the last country house constructed in Cleveland Park. In 1930, the house was enlarged into a Georgian-style mansion. It was captured in the photograph seen here dated November 24, 1949. (HSW.)

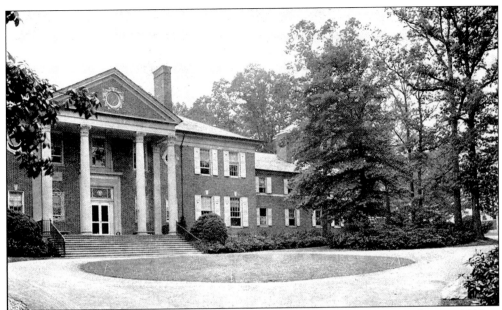

Tregaron was first known as "The Causeway" when it was built in 1912. Seen here in 1918, it was commissioned by real estate mogul James and Alice Parmelee and designed by architect Charles Adams Platt as a year-round grand estate, not just a summer house as its predecessors had been. When Joseph Davies and his wife Marjorie Merriweather Post bought it in 1942, they named the estate Tregaron after the Davies family village in Wales. (Authors.)

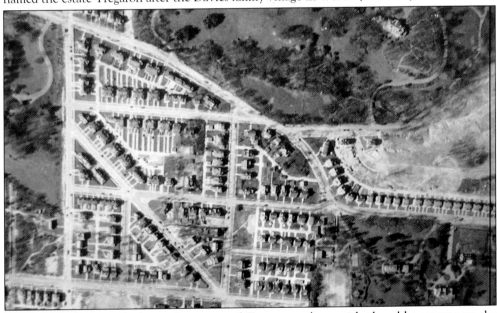

This aerial photograph shows the estate of Tregaron, along with the old entrance to the Beauvoir Mansion at the intersection of Woodley Road and 34th Street. Tregaron was pictured in the August 1914 issue of *Architectural Record* when Herbert Croly wrote, "It was matured on the day that is was finished; and it will still look fresh and young on the day that it is torn down." Fortunately, that day has not come, and it is now home to the International School. (NA.)

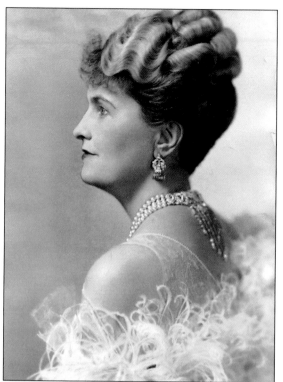

Mrs. Joseph E. Davies was better known as Marjorie Merriweather Post, heir to the "Post" cereal fortune. Her husband at the time she resided at Tregaron was the chairman of the Inaugural Committee of President Roosevelt when this photograph was taken on January 18, 1937. (MLK.)

The Russian-style dacha was built on the grounds of The Causeway in 1945 by Joseph Davies and Marjorie Post, styled after houses found outside Moscow. The dacha was designed by James T. Thompson and built by the Evans & Hunt construction company to serve as Joseph's office. The two plate windows seen in this picture face the National Cathedral, which is visible across the wide-open lawns of Twin Oaks. The structure was later recreated at Hillwood. (Authors.)

The front gate and "causeway," after which the house was originally named, is seen here amid its lavish and wooded grounds, set apart from the rapidly developing Cleveland Park neighborhood. Architect Charles Platt had hired landscape architect Ellen Biddle Shipman to design its formal grounds. (Authors.)

Joseph E. Davies and Marjorie Merriweather Post were photographed in the rose garden at Tregaron after Mr. Davies returned from a meeting with Joseph Stalin on behalf of President Roosevelt on June 2, 1939. He had earlier been appointed as ambassador to the Soviet Union from 1936 to 1938. (MLK.)

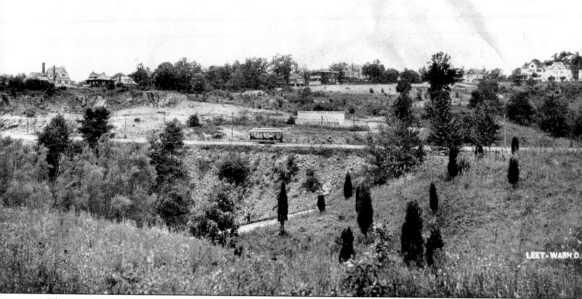

This 1900 view looking west across Connecticut Avenue shows a summer trolley and a horse-and-buggy, riding past the stone quarry and the backs of houses on Newark Street, as well as the houses on Highland Place and Ashley Terrace. Note the sign in the middle of the image that advertises "Connecticut Avenue Highlands" lots for sale by broker Milton E. Gordon. (CPHS.)

This seldom-seen view toward the city of Washington from Cleveland and Woodley Parks illustrates the rural nature of the neighborhoods that remained even long after their large estates were divided into individual building lots for the construction of single-family homes. (CPHS.)

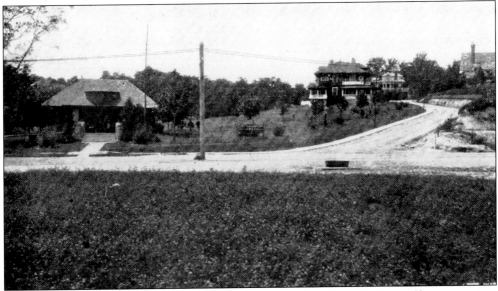

This view looking west across Connecticut Avenue and up Newark Street (from a vantage point that is today the site of a CVS drug store) shows a stone building at left built by a real-estate developer as both a community center and a place to wait for the trolley service that ran down Connecticut Avenue. The Cleveland Park Library now stands at this exact location. In the center, along Connecticut Avenue, a watering trough for horses can be seen. Directly behind is a house with three porches at 2934 Newark, home to John H. Ellis, a clerk at the War Department in 1914. The house to the extreme right is 2941 Newark, home of Jas B. Henderson, a partner in the furniture store at 1109 F Street (in 1914) called "R.W. & J.B. Henderson's." (CPHS.)

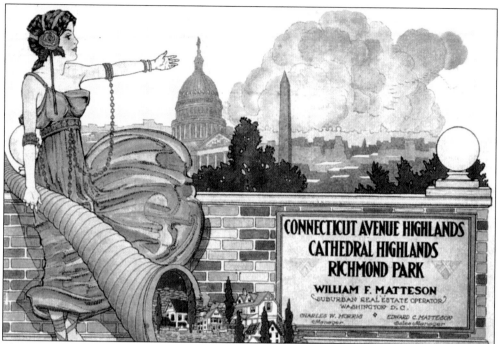

This elegant advertisement promises a cornucopia filled with gold coins for residents of the newly emerging Cleveland Park neighborhood. It appeared in developer William F. Matteson's 1910 advertising booklet for various subdivision names, all of which would become Cleveland Park. (MLK.)

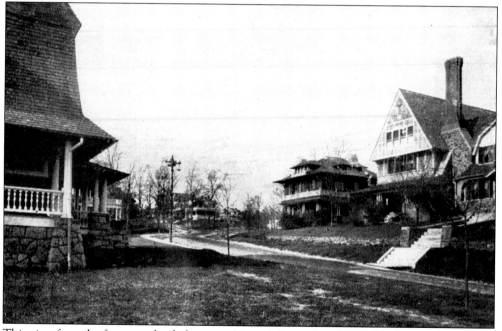

This view from the front porch of a home on Newark Street has changed little since it appeared in the Moore & Hill real estate brochure in 1904, with the exception of mature trees that now line the street. (CPHS.)

The two houses at 3432 and 3434 Ashley Terrace are seen here long before surrounding houses were built, and the street itself was paved with wooden boards. Architect Robert Head designed both houses in 1899. By 1914, only seven houses lined the street. The one at 3432 was home to Matthew A. Cram, an assistant to the Attorney General, and the one at 3434 was home to lawyer Frank J. Hogan. (CPHS.)

This undated yet early picture of the house at 2962 Ordway Street shows its elegant retaining wall at the sidewalk, and large neighboring houses with many open side yards that have since been built upon with homes. The block was completely vacant of homes in 1914, but by 1920, it was lined with 15 homes. (CPHS.)

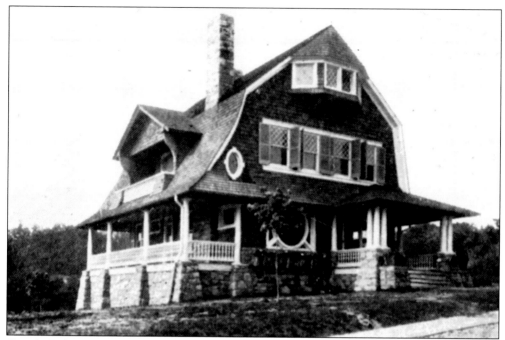

Comdr. Robert Peary, who is credited with discovering the location of the North Pole in 1909, called the dwelling at 2940 Newark Street home. Legend has it that the large, round window seen on the façade was designed to mimic a porthole in order to make the commander feel that he was on a ship. (CPHS.)

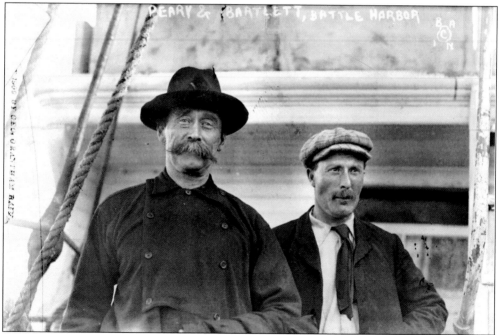

Capt. Bob Bartlett, right, and Robert Edwin Peary, left, resident of 2940 Newark Street, are seen in 1909 standing on a ship in Battle Harbor, Labrador, Canada. Peary was born in 1826 and died in Washington in 1920. (Photograph copyright George Grantham Bain.) (LOC.)

This 1904 view from 3225 Highland Place in Cleveland Park illustrates the unpaved streets and idyllic setting of the early suburb at the time. (CPHS.)

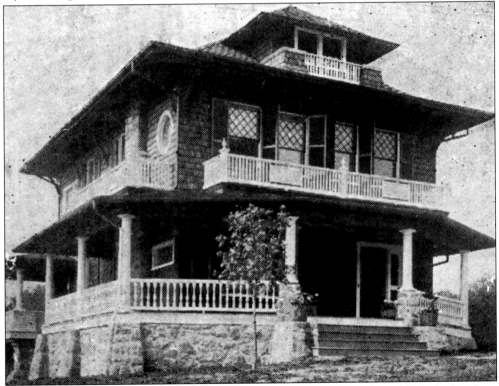

This advertisement for a recently sold home in Cleveland Park appeared in a 1904 sales brochure and was typical of the real estate offerings of the era. (CPHS.)

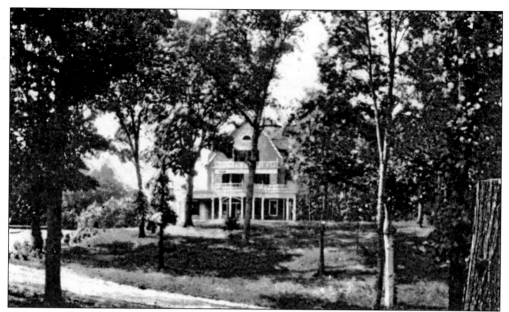

Homes in Cleveland Park, such as this one photographed in 1904, were frequently surrounded by large lawns, gardens, and mature trees that were retained to provide shade and comfort. They were located far away from the more typical urban townhouses to which many developers hoped to lure potential residents. (CPHS.)

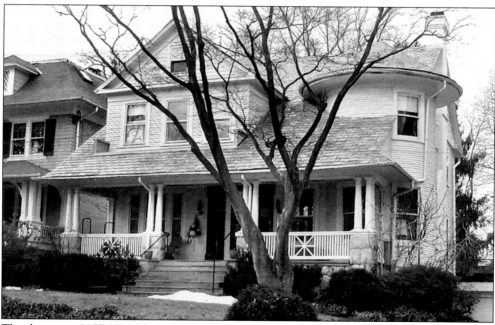

This house at 2957 Newark Street was built in 1909 for the Ashbough family, who moved to Cleveland Park from Wichita, Kansas. They apparently liked their house in Kansas so much that they brought the plans with them and had a copy of the same house built for them on Newark Street. Samuel S. Ashbough was then an attorney in the Department of Justice. (Authors.)

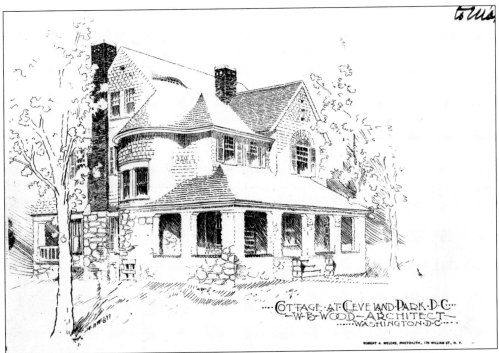

This architectural drawing for a residence for Dr. Elmer Southern was labeled "cottage at Cleveland Park" by architect Waddy B. Wood, who also designed a townhouse for the doctor downtown. Wood's writing on the image indicates that he submitted it to the *Architect and Building News* for possible publication, but it is unknown if it was ever built. (LOC.)

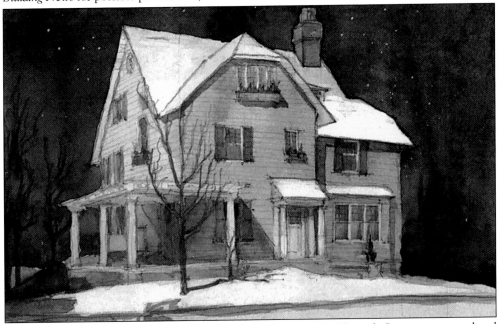

This architectural drawing for Miss McEwen's house at 3324 Newark Street was completed by architect Arthur B. Heaton in 1906. The 1914 city directory for Washington, however, indicated that the house was then "closed." (LOC.)

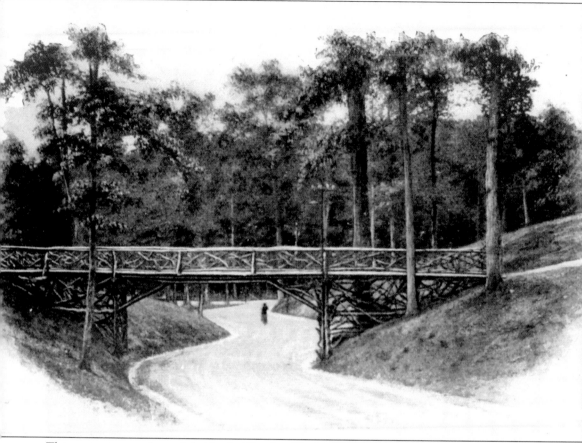

This quaint image of a rustic bridge in Cleveland Park appeared in a 1904 sales brochure printed to attract urban dwellers to the country life that the neighborhood promised its new residents. This bridge existed for a short time and carried Newark Street over a portion of Reno Road. Macomb Street is depicted in the distance.(CPHS.)

This very rare image looking north towards Ashley Terrace across Newark Street appeared in the *Washington Star* newspaper in 1906 as part of a series the paper featured on intersections throughout the city. (MLK.)

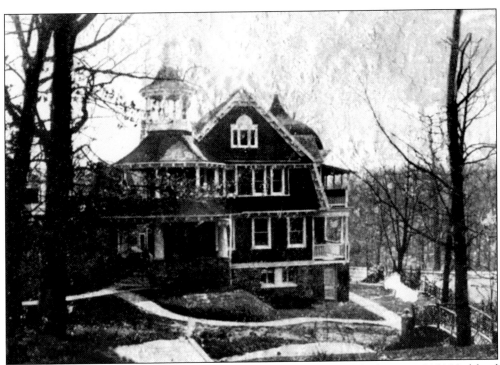

This picture, taken in 1910, shows the wood shingles on the roof of the house at 3154 Highland Place, which was replaced in 1916 with red clay tiles, dramatically altering its appearance. In 1914, it was home to John J. Noonan, proprietor of the "Stag Hotel and Virginia Theater" located at 608 9th Street, the "Maryland Quick Lunch" next door at 610 9th Street, and the "F.F.V. Lunch" at 1008 Pennsylvania Avenue, N.W. (CPHS.)

Klingle Valley is seen here in 1900. The Klingle Brook flows under a dirt Klingle Road with noticeably thinner undergrowth than today. In the distance would have been the old Klingle Valley bridge. The photographer noted that from this location, "one could hear a chorus of wolf music emanating from the neighboring Zoo." (Authors.)

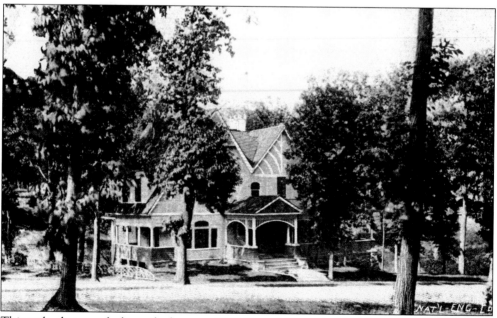

This early photograph shows the house at 3149 Newark Street in 1914, home to Mrs. Melissa T. Skeer and her daughters Tina and Velma. (CPHS.)

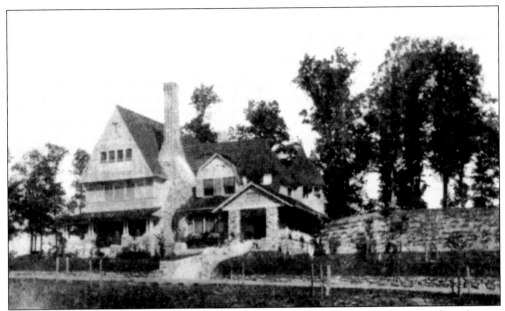

This early picture of the house at 2941 Newark Street shows its extensive grounds and stone retaining wall. From about 1910, it was home to James B. Henderson of the Henderson Furniture Store at 11th and F Streets, N.W. (CPHS.)

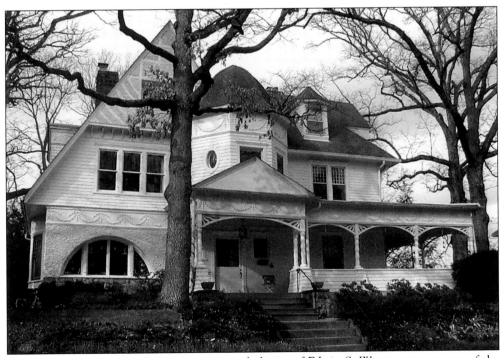

The house at 3035 Newark Street was an early home of Edwin S. Wescott, a treasurer of the Home Building Association and owner of a "Real Estate, Loans, Notary Public, and Insurance" business at 1907 Pennsylvania Avenue. (Authors.)

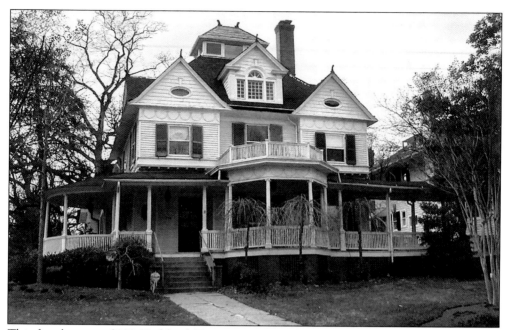

This fine home at 3100 Highland Terrace was owned in 1920 by insurance agent Oscar J. Ricketts. (Authors.)

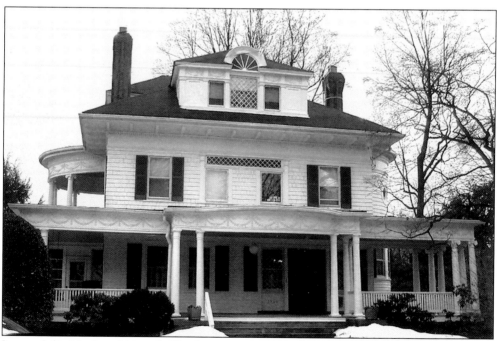

Lawyer John Mock and his wife Charlotte were owners of this house at 2960 Newark Street in 1935. (Authors.)

American Federation of Labor founder Samuel Gompers owned the house at 3501 Ordway Street. He is seen here seated on a lecture platform in 1915 at the Federal Commission on Industrial Relations conference in New York City. (Photograph by George Grantham Bain.) (LOC.)

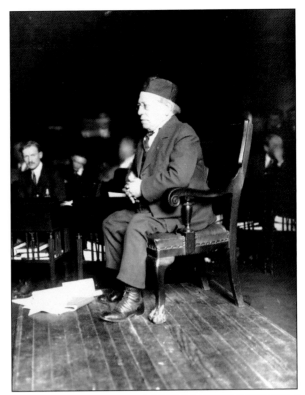

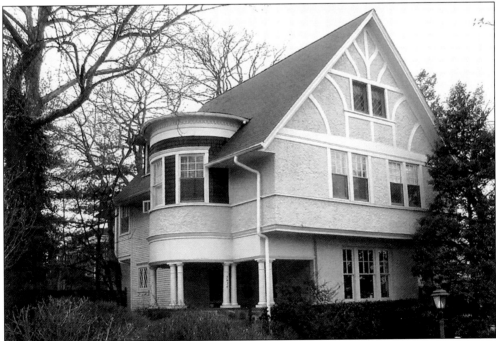

The Secretary of the Chamber of Commerce David A. Skinner and his wife Edna called this house at 3434 Ashley Terrace home in 1935. They lived here along with their daughter Annie, a registered nurse. (Authors.)

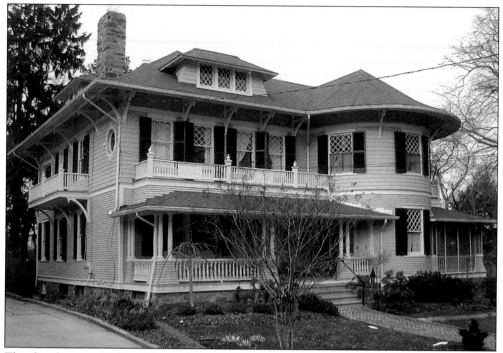

This fine house, which was located at 2955 Newark Street, was home in 1914 to William L. Yaeger, a public accountant and auditor who maintained an office in the Metropolitan Bank Building. (Authors.)

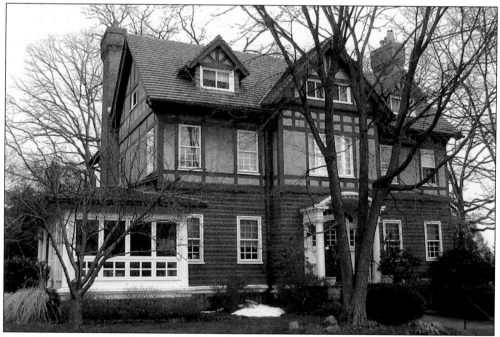

James Sharp owned this house at 3101 Highland Terrace in 1914. He noted in that year's city directory that he was the president of the Eastern Viavi Company, then located in the Colorado Building downtown. (Authors.)

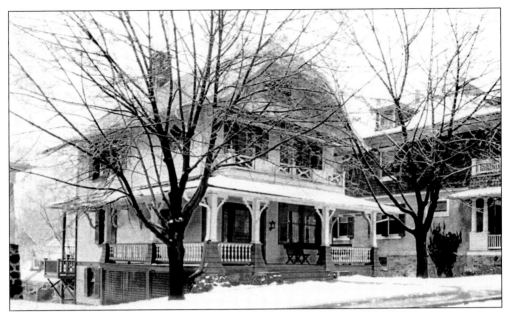

Ruth Merwin lived at this 2946 Newark Street home beginning in 1918. It is pictured about 1960 in the snow. Her father, Herbert E. Merwin, was listed in the 1920 city directory as a petrologist at the nearby geophysical laboratory. (CPHS.)

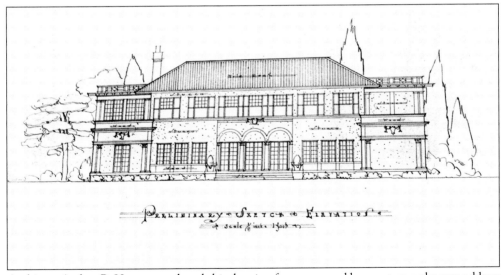

Architect Arthur B. Heaton produced this drawing for a proposed house at an unknown address for John C. Letts in Cleveland Park in 1915. Letts was then president of the Letts Grocery Company at the time and later resided at 2029 Connecticut Avenue. (LOC.)

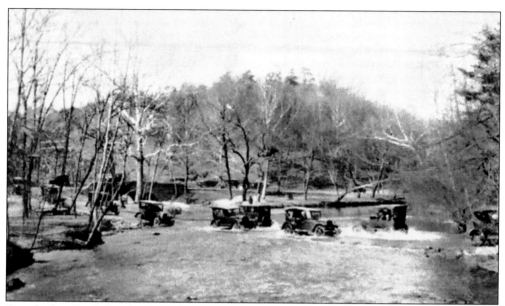

Cars fording Rock Creek at Broad Branch are pictured here in March 1926. During the 1920s, a road connecting Broad Branch with Tilden Street was built along the north side of Rock Creek. so that drivers were no longer forced to cross it. Amazingly, the contemporary bridge built at the intersection of Blagden, Beach Drive, and Broad Branch was not constructed until 1954. (MLK.)

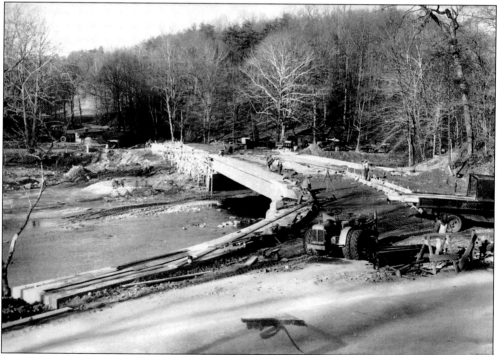

This image of the intersection of Beach Drive, Blagden, and Broad Branch was taken in January 1954 at the time of the contemporary interchange's construction. This project cost $300,000 and was part of a city-wide effort to rehabilitate 16 small parks. (MLK.)

Three

THE NATIONAL BUREAU
OF STANDARDS AND
THE NATIONAL CATHEDRAL

Within Cleveland Park's shadow were two massive building projects that altered the daily lives of citizens and provided employment: the National Bureau of Standards along Connecticut Avenue at Van Ness Street and the National Cathedral at the intersection of Wisconsin and Woodley Road.

The National Bureau of Standards was created under a Congressional grant in 1867 as the Office of Standard Weights and Measures in response to the irregular educational system of the United States. In 1901, an Act of Congress changed its name to the National Bureau of Standards, and the government began to look for a suitable location for the expanding role of the agency. Building began that same year, and within the next two decades a vast campus of laboratories, office buildings, testing facilities, and sometimes bizarre-looking structures took shape along Van Ness Street in Cleveland Park. Its companion was the community's Geophysical Laboratory, begun in 1907.

The Bureau was mandated with testing new materials for future manufacturing and consumer consumption, as well as establishing a wide variety of standards for measuring heat, fuel, distances, and the inherent qualities of newly developing materials at the time. For example, the Metallurgy Division was founded at the facility in 1913, with early investigations focusing on the constituents of railroad iron and steel, heat stress, heat treatment, and related problems in the manufacturing process. Many of its workers lived within an easy walking distance to their homes. Needing additional space and a consolidated work environment, the Standards moved to a suburban location in Maryland, and was renamed the National Institute of Standards and Technology. Its campus buildings were torn down in the 1960s to make way for the University of the District of Columbia campus and the Intelsat Building seen on its site today.

The idea for a National Cathedral was born in 1791, when President George Washington commissioned Maj. Pierre L'Enfant to design an overall plan for the future seat of government. Efforts to build the Washington National Cathedral, officially named the Cathedral Church of Saint Peter and Saint Paul, stalled for over a century until 1893, when Congress granted a charter to the Protestant Episcopal Cathedral Foundation of the District of Columbia. The Cathedral School for girls was established in 1900, and in 1905, the St. Albans School for boys was founded, as both schools preceded the actual Cathedral itself.

The first of bishop of Washington, Rev. Dr. Henry Yates Satterlee, was instrumental in securing land atop Mount St. Alban for the Cathedral. On September 29, 1907, President Theodore Roosevelt, in front of a crowd of 10,000 onlookers, struck the Cathedral foundation stone with the same mallet used by George Washington to dedicate the United States Capitol in 1793. Since that time, every United States president has either attended services or visited the Washington National Cathedral and has been witness to the longest-running building site in Washington. On Sept. 29, 1990—83 years to the day of the dedication—the west towers of the Cathedral were completed. This final stage of construction brought the total cost of the building to $65 million.

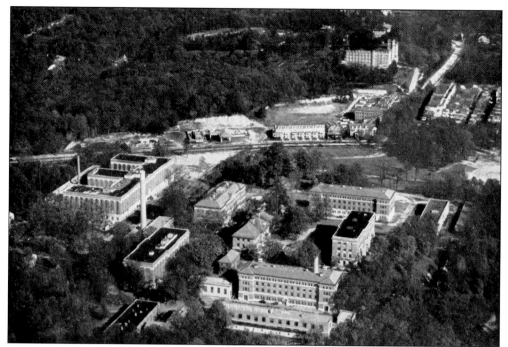

This aerial view shows the massive size of the National Bureau of Standards along Connecticut Avenue that was begun in 1901. It outgrew the site 60 years later, and its many handsome buildings were razed when the agency moved to Maryland. (MLK.)

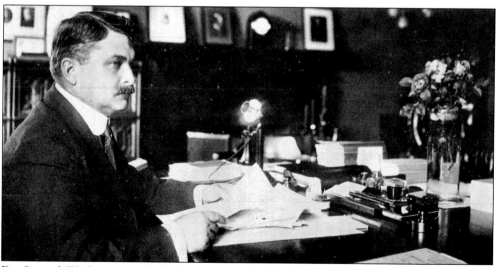

Dr. Samuel W. Stratton, who had studied at the University of Illinois and at age 38 was a full professor of physics at the University of Chicago, is seen here at his desk in the old south building in 1905. He was appointed by Lyman J. Gage, Secretary of the Treasury, to write a report proposing legislation for the formation of a national standards laboratory. Stratton took office on October 28, 1899. (MLK.)

Despite the complicated mission of the Bureau, the construction of its buildings was rather elementary. This mule was used to level the terrain for construction of the Chemistry Building about 1905. The Low Temperature Building can be seen in the background. (MLK.)

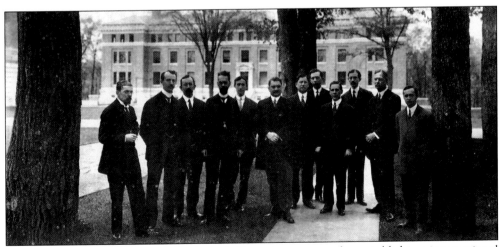

Members of the International Technical Committee meet after establishing international values for ampere, ohm, and volt. They are, from left to right, F. Laporte (France), Sir Frank Smith (England), Dr. Frank A. Wolf Jr., Dr. W. Jaeger (Germany), M.P. Shoemaker, Dr. Stratton, Dr. Frank Wenner, Dr. A.S. McDaniel, G.E. Post, Dr. Frederick W. Grover, Dr. Rosa, and George W. Vinal. (MLK.)

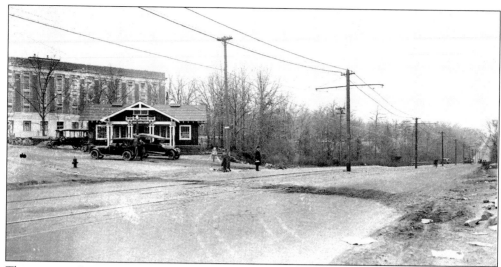

This view at Connecticut Avenue and Van Ness Street (looking northwest up Connecticut Avenue) shows the Standard Store Company. It was established in 1917 by the residents of Cleveland Park, who owned the company as shareholders. Common shares sold for a dollar with preferred stock selling for $25. A total of $7,500 was raised through the sales of stock, a six percent interest was guaranteed on all preferred stock, and common stock holders received dividends proportional to their purchases at the store. The store made only cash sales in all cases except for customers who kept deposits with the store, for which they received interest. Note the trolley that is seen approaching from the right as a soldier and a Bureau employee wait at the stop. (MLK.)

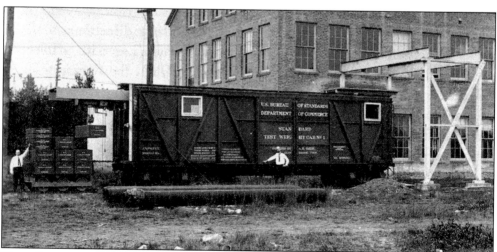

These Bureau employees are seen testing the weight capacity of a railroad car on a short track set up on the agency's grounds. Their experiment would then be applied to the railroad industry to ensure safe load capacities in boxcars.

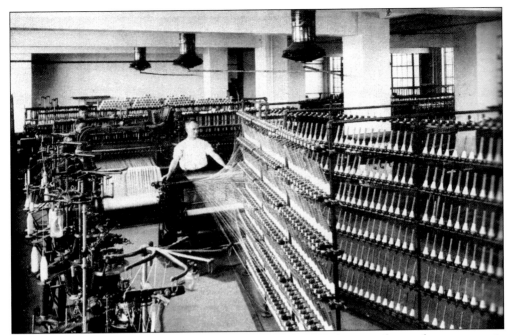

After World War I, the Bureau turned its attention towards researching advancements in industry. Pictured here are knitting machines and a large creel, which was used to twist cotton and yarn. The question of just how many twists are necessary to secure the greatest efficiency is one that has troubled manufacturers for years and the Bureau had undertaken to solve their problem. (MLK.)

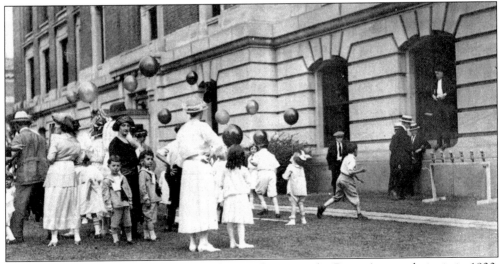

Residents from Cleveland Park are seen here gathering at the Bureau's annual picnic in 1920, hosted by the Bureau's founder, Dr. Stratton. (MLK.)

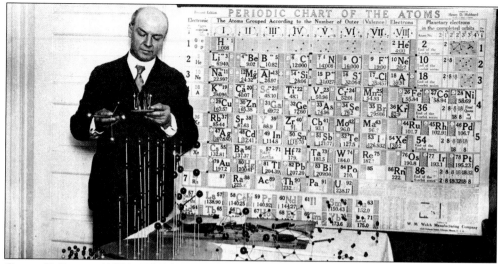

George K. Burgess (1874–1932) became the second director of the Bureau on April 21, 1923. A graduate of both MIT and the Sorbonne, Burgess had previously been the chief of metallurgy at the Bureau and had taught at the University of California beginning in 1902. (MLK.)

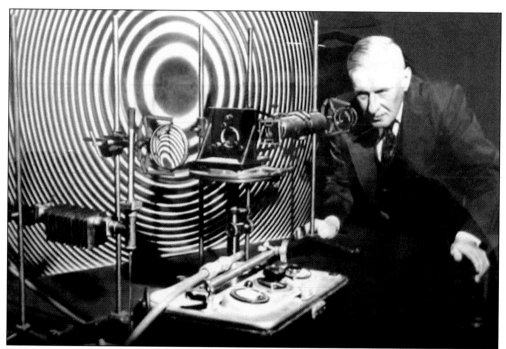

The Bureau and the Atomic Energy Commission announced the availability of an ultimate standard of length to science and industry. The standards consist of spectroscopic lamps containing a single pure isotope of mercury. Dr. William F. Meggers, seen here, positions the eyepiece of the optical train prior to observing the circular interference fringes of green light. (LOC.)

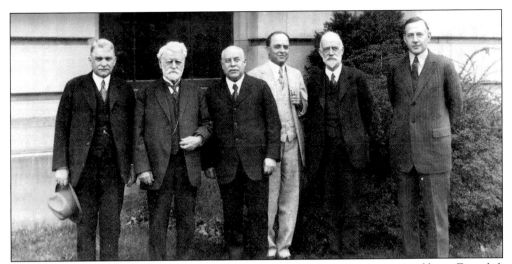

The Visiting Committee of the Secretary of Commerce to the Bureau is pictured here. From left to right are Dr. Stratton, president of MIT; Ambrose Swasey; Dr. Burgess, director of National Bureau of Standards; W.R. Whitney, director of research at General Electric Corp; W.F. Durand, professor of mechanical engineering at Leland Sanford University and president of the American Society of Mechanical Engineering; and Gano Dunn. (MLK.)

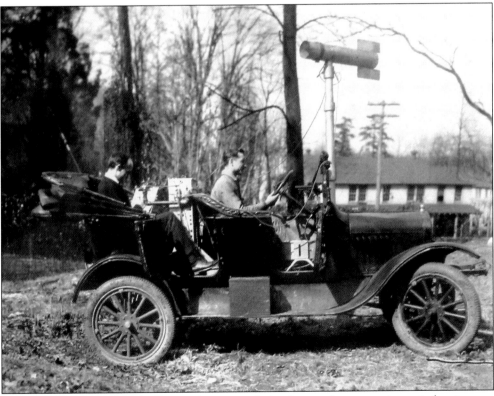

This test car was used at the Bureau for testing fuel values and consumption, wind resistance, and carbon troubles, probably a result of an inquiry from the automobile industry. (LOC.)

The buildings at the Bureau pictured here include the following: (from left to right) West Building, South Building, Low Temperature Building, and the North Building. (MLK.)

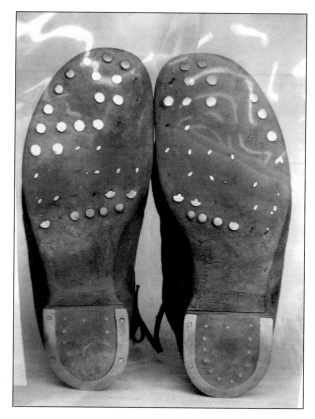

Tests at the Bureau have not always been complicated. One performed during the Depression was used to determine the value of the hobnail in saving shoe leather. The sole in the picture was subjected to wear similar to that occurring in 90 days of actual use, and shows that the leather was barely worn, while the hobs are only partially worn off. (LOC.)

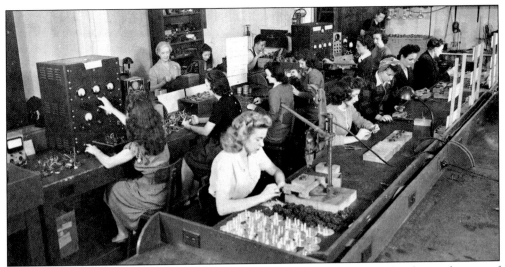

Seen in this image is the Bureau's workshop (with a female work force) for the production of prototype proximity fuses during World War II. (MLK.)

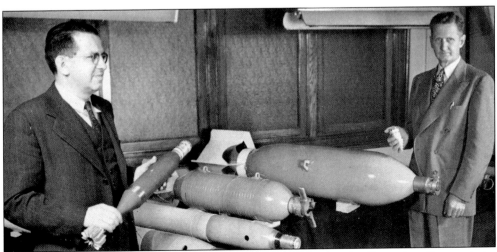

Harry Diamond (left) and Dr. Alexander Ellett proudly display the Bureau's radio proximity fuses and the bombs to which they were attached. (MLK.)

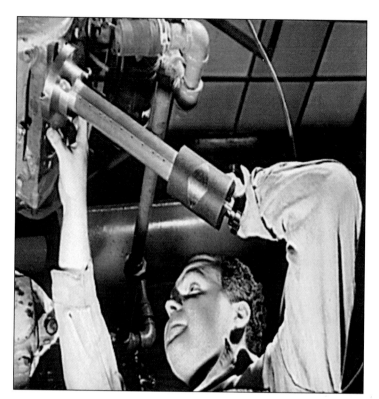

In this photograph (which could be a still from a vintage science fiction movie), Emmet L. Reed conducts an experiment at the Bureau on the wear rate of engines run on synthetic fuels. (LOC.)

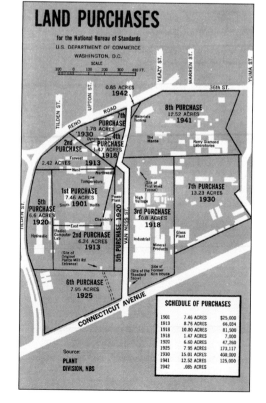

This map shows the rather complex locations and dates of the Bureau's purchase of multiple parcels of land, which would eventually be consolidated as the Bureau's Cleveland Park campus. (MLK.)

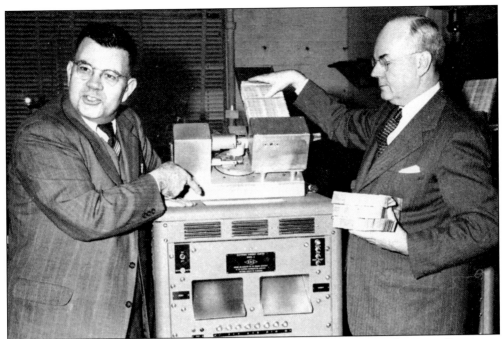

Dr. Condon (left) and John F. Snyder, Secretary of the Treasury, enthusiastically test an electronic currency counter, now common in every bank in America, with "worn-out" dollar bills. (MLK.)

As a completely separate facility, the Geophysical Laboratory was built in 1907 at 5241 Broad Branch Road as one of five research departments of the Carnegie Institution of Washington. Its first director was Arthur L. Day, and it was one of the first privately funded scientific research organizations in the United States. Pictured here is R.C. Meyer with a two-meter Van de Graaff generator at the Department of Terrestrial Magnetism on April 16, 1936. (LOC.)

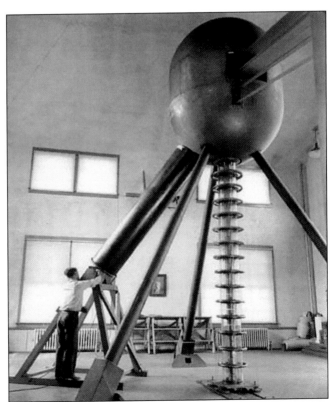

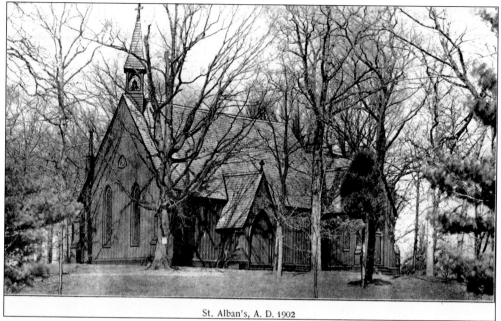

St. Alban's, A. D. 1902

A 1902 image of St. Alban's Episcopal Church is seen here. The church was founded in 1851 and is geographically part of the National Cathedral grounds, although not officially tied to the Cathedral. The church is located on Mount Alban, which was purchased by Joseph Nourse in 1813. When his daughter, Phoebe, died in 1850, she left $40 in gold for the creation of a free church on Mount Alban. Still in the same location, the church was encased in stone. (MLK.)

This image shows the clearing of the ground for the site of the National Cathedral. The white house in the trees at the center of the picture was once located along Wisconsin Avenue. St. Alban Church can be seen at the far left. (NCA.)

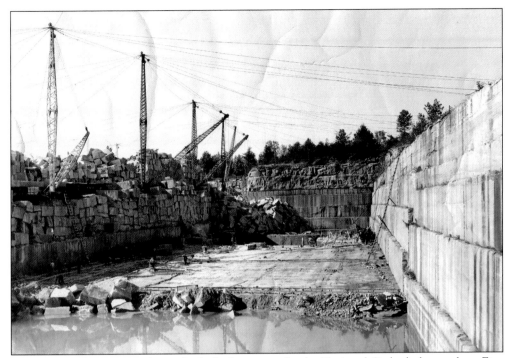

This is the Indiana quarry from which the limestone for the National Cathedral was taken. Five cranes and a system of temporary narrow-gauge train tracks laid in the quarry bottom were used to move the large chunks of rough limestone to Washington. Here we can see four of the cranes and the massive scale of the quarry. (NCA.)

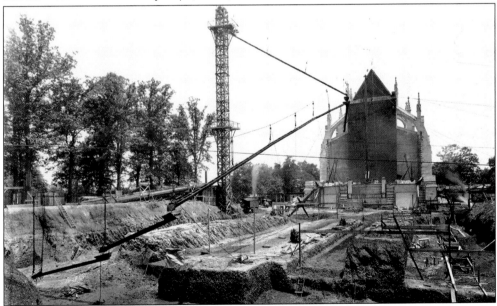

In the center of this photograph, taken on July 15, 1922, is the tower that was built for the laying of the cement foundation of the Cathedral. From the one tower a series of pipes were suspended from an elaborate network of ropes, pulleys, and wires, which delivered cement to where it was needed. (NCA.)

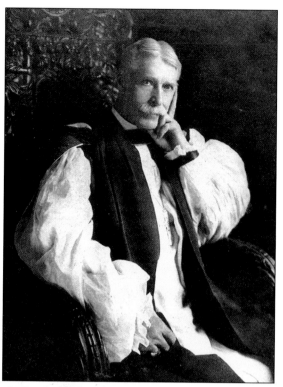

The first of bishop of Washington, Rev. Dr. Henry Yates Satterlee, was instrumental in securing land atop Mount St. Alban for the Cathedral, and on September 29, 1907, he joined President Theodore Roosevelt in front of a crowd of 10,000 onlookers to lay Cathedral foundation stone. (NCA.)

The ceremony for the laying of the foundation stone in 1907 is pictured below. All of those seated behind the long table are bishops. President Theodore Roosevelt presided over the ceremony. (NCA.)

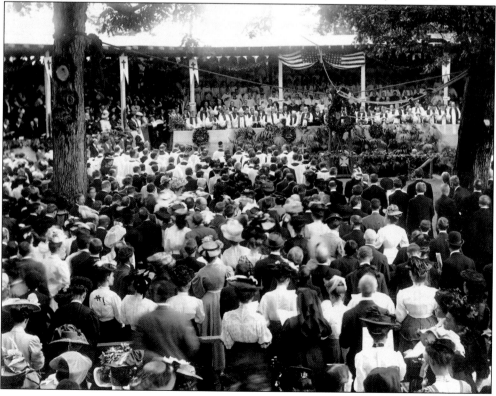

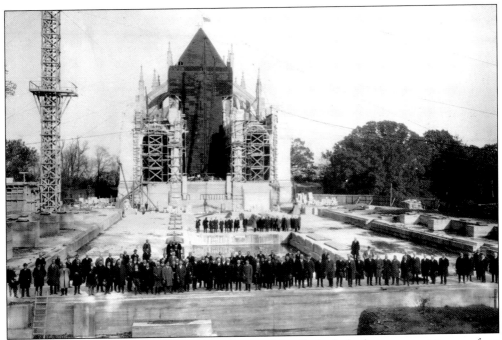

Prominent persons involved in the construction of the Cathedral take a moment to pose for a group portrait, above, in 1923. (NCA.)

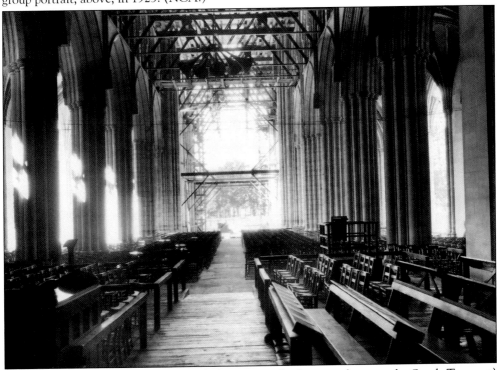

This fascinating view from the Cathedral's crossing (looking south across the South Transept) was taken in 1928 and shows the incomplete and open south wall with scaffolding and trees in the distance. (NCA.)

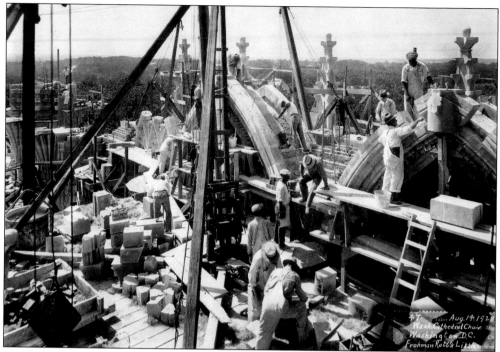

Builders working for George A. Fuller Co. are seen here assembling pre-carved and numbered stones on the choir section of the Cathedral on August 14, 1928. (NCA.)

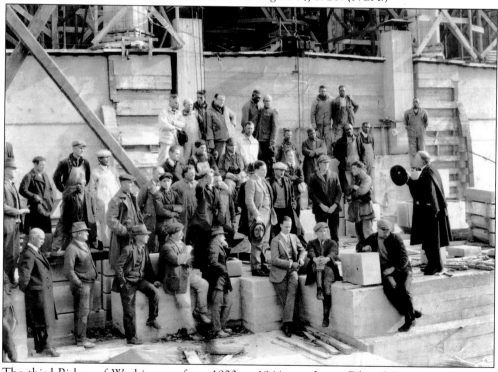

The third Bishop of Washington, from 1923 to 1944, was James Edward Freeman, seen here addressing construction workers in 1927. (NCA.)

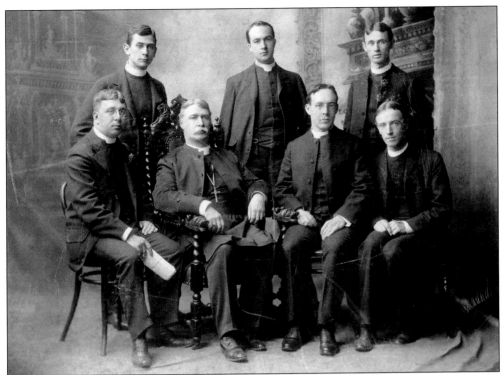

Bishop Henry Yates Satterlee is pictured here in the front row, second from left, at a meeting held to inspect the construction progress. Philip M. Rhinelander is seen in the front row, far right. (NCA.)

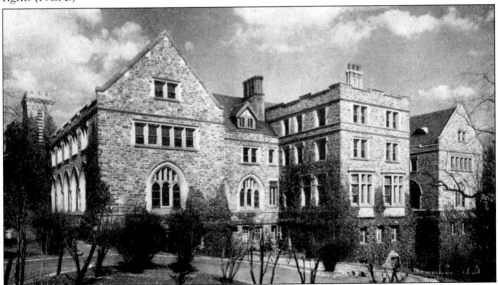

The first building at St. Albans, in 1905, was known as "The Lane Johnston Choir School for Boys of the Washington Cathedral." At the time of its construction, it was praised as "the best planned single school building in the country" and stated its goal as "turning unintentional boys into intentional men." Many future influential men were schooled at St. Albans, including former Vice President Al Gore, who graduated in 1965. (MLK.)

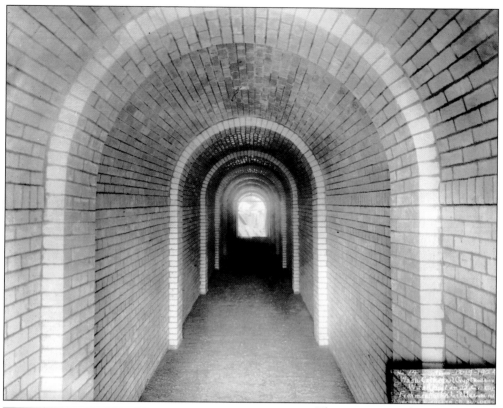

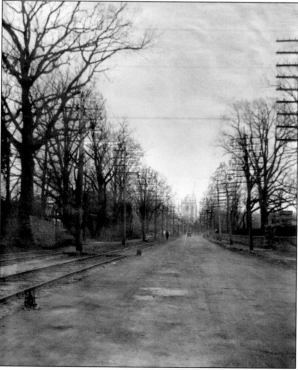

This image was taken on December 19, 1924 and shows a little-known tunnel that connects the Cathedral (near the Resurrection Chapel at the crypt level) to the lawns east of the Bishops Garden. The tunnel goes under South Road, which leads from the Herb Cottage to the Deanery, and was once part of an underpass used to haul soil out of the foundation and building materials into the construction site. (NCA.)

This sleepy image of Wisconsin Avenue was taken in March 1918, and shows the partially completed Cathedral in the background. The wall on the left side of the street was the old boundary of the Friendship estate before the widening of Wisconsin Avenue. (NCA.)

Four

THE BUILDING BOOM

In 1903, Cleveland Park was home to only about 60 architect-designed houses, each set among heavily tree-lined streets with ample side yards and landscaped grounds. However, Thomas Waggaman, owner of the Cleveland Park Company, filed for bankruptcy in 1905, and was forced to auction off his land holdings. Several entrepreneurial developers purchased multiple lots, such as W.C. & A.N. Miller, who began to fill in the vacant lots in 1910s and 1920s with smaller, more affordable dwellings. They first focused their efforts along Woodley Road and 34th and 35th Streets. Other developers included Charles and Louise Taylor and W.D. Sterrett, who completed the majority of houses in the 1920s and 1930s. Architects such as Appleton P. Clark, Marsh and Peter, Hornblower and Marshall, William Lescaze, and even modernist I.M. Pei all added their designs to the built environment.

The typical smaller, single-family homes were built in rows along the streets of Cleveland Park and were also joined by several very large estates in the 1920s. These included the 59-room Firenze on Broad Branch Road, while bank president George White built an impressive mansion at 2800 Upton Street. The completion of a new Klingle Valley bridge in the 1930s and the modernization of area roadways all contributed to a booming real estate market in Cleveland Park.

The boom in residential development necessitated the erection of schools, churches, and the neighborhood library. John Eaton Elementary School opened its doors in 1911 and was expanded several times later. The Academy of the Holy Cross at 2900 Van Ness Street was built in the 1920s and was later known as the Dunbarton College, educating many children of Cleveland Park residents. Agnes Miller donated her house in 1922 to be used as the home of the Cleveland Park Club, which still prospers today. Churches such as the Cleveland Park Congregational Church also joined the growing community in 1923.

This house at 3310 Macomb Street was featured in a sale advertisement of the National Savings and Trust Company in 1921. Cleveland Park residents at this time were mostly comprised of professionals in management positions. (LOC.)

Amateur photographer John Wymer took the image below of the homes along the north side of Tilden Street, east of Connecticut Avenue, on March 27, 1952. They remain much as they appeared over 50 years later. (HSW.)

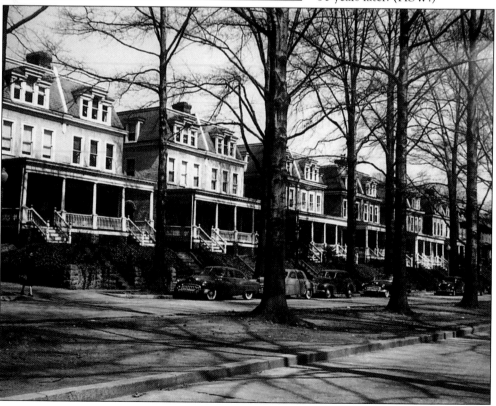

This home at 3414 Macomb Street was sold in 1921 when this photograph was used in the advertisement. Cleveland Park home prices were considered expensive in the city, often ranging between $5,000 and $8,000. (LOC.)

Henry A. Willard II, whose grandfather was one of the founders of the famed Willard Hotel, resided at 2801 Tilden Street for much of his life. He was born in 1902, and when not in residence at the Tilden Street house at the edge of Rock Creek, he spent his summers on Nantucket. (LOC.)

Francis Griffith Newlands, Senator from Nevada and owner of the Chevy Chase Land Company, owned most of the land adjoining Connecticut Avenue from Calvert Street to Chevy Chase, Maryland. His creation of a five-mile route for the Rock Creek Railway on that same stretch introduced easy transportation for Cleveland Park residents to and from downtown Washington.

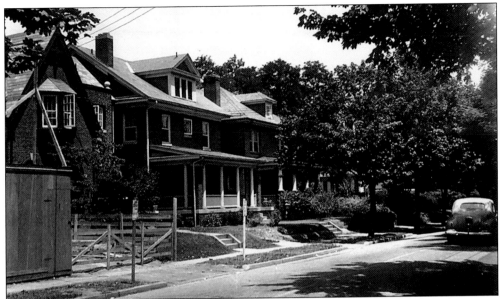

This image of Porter Street, east of Wisconsin Avenue, was taken by photographer John Wymer on July 9, 1949. The large plywood structure at left was actually a storage shed for construction materials that was typically built at the sidewalk during construction of a home or building. (HSW.)

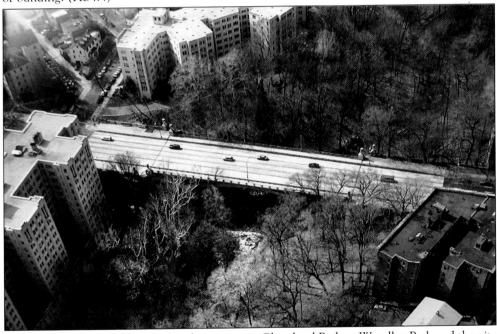

The modern Klingle Valley Bridge that connects Cleveland Park to Woodley Park and the city of Washington was built between 1930 and 1932. Replacing a much smaller, steel truss bridge built in 1891, the modern bridge was designed by Paul Cret, with Modjeski, Masters & Chase as chief engineers—the same team that collaborated on the Calvert Street (Duke Ellington) Bridge. The single-arch steel span was deliberately simple so that it would not interfere with the picturesque landscape of Rock Creek Valley. (LOC.)

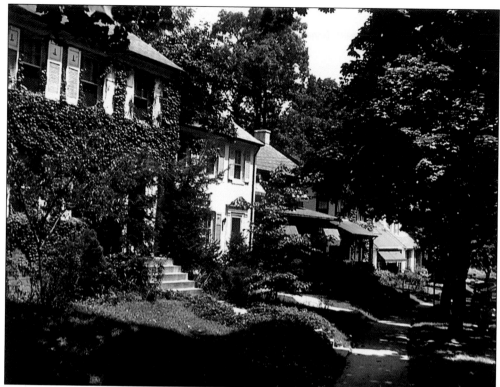

This leafy, utopian view of the north side of Porter Street, east of 30th Street, was photographed by John Wymer on July 30, 1949. (HSW.)

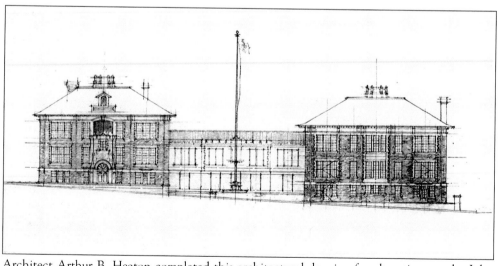

Architect Arthur B. Heaton completed this architectural drawing for alterations to the John Eaton School at 34th and Lowell Place in 1921. The school opened in 1911, and was named after the United States Commissioner of Education, who resided in a large wood-frame house at 712 East Capitol Street on Capitol Hill. (LOC.)

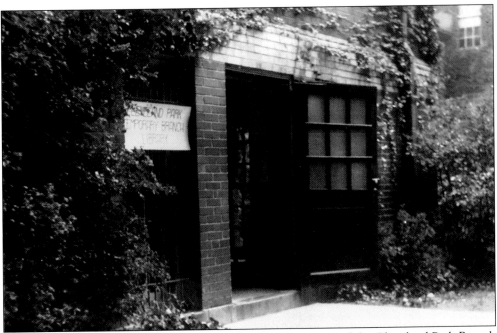

More than likely, few residents today remember that the origins of the Cleveland Park Branch Library began with temporary quarters at the John Eaton School, as seen here. (MLK.)

The John Eaton pre-kindergarten class of 1949 is seen here in front of their ivy-clad school, with teacher Miss Falls pictured at the center. Beginning in 1945, the PTA was approached by the teachers to provide art materials for art class, a curriculum not previously offered. The PTA agreed and provided $7 for chalk and $3.20 for paper used for finger painting. (CPHS.)

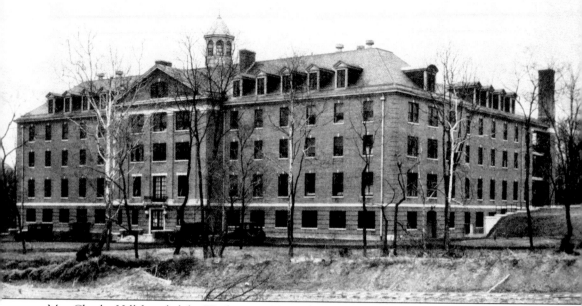

Mrs. Charles Hill founded the Washington Home for Incurables in 1888 with "its special object being the care of indigent incurable persons of both sexes for whom no other provision exists." In 1924, the home moved to its present location on Upton Street. The brick facility, with screened porches, would stand at this site for the next 64 years, before being replaced with a series of modern structures. (MLK.)

The impressive open-air architecture of the Home for the Incurables lobby is seen here, as featured in the May 20, 1926 issue of *American Architect*. Architect Lynch Luquer designed it. (Authors.)

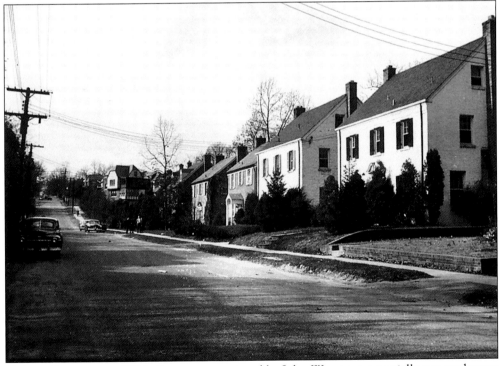

Ordway Street, west of 34th Street, was captured by John Wymer as a partially unpaved street without curbs on November 24, 1949. (HSW.)

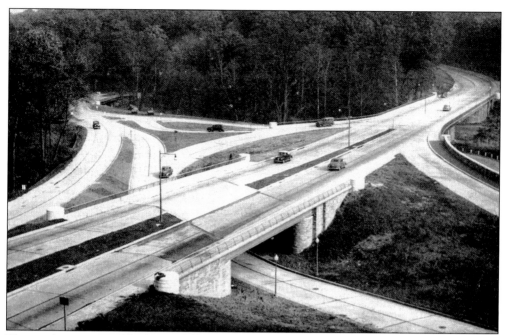

The modernization of highways following World War II was not limited to rural areas, as these c. 1955 drivers enjoy the newly configured intersection of Klingle Road and Porter Street. Just 20 years earlier, cars were forced to traverse the Rock Creek riverbed over flattened stones. (MLK.)

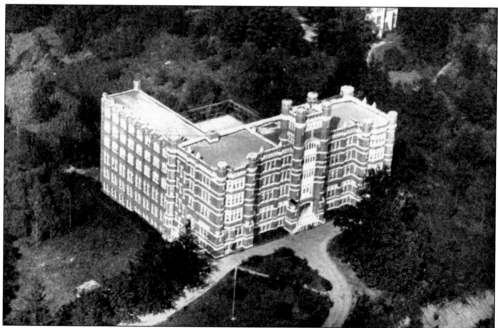

The Holy Cross Academy, seen here, was later known as Dunbarton College. The area around the Holy Cross Academy has been part of several neighborhoods, from Richmond Park in the 1880s, to Fernwood Heights in 1916, to the current Van Ness. The small residential house seen in the background was razed in the late 1990s. (MLK.)

Entering students at Dunbarton College (Holy Cross) were greeted on their first day of classes by one of the Sisters of the Holy Cross, who also served as their mentors and teachers. The gothic structure at 2900 Van Ness Street was built in the 1920s for the Academy of the Holy Cross, a Catholic Institution for the education of young women under the care of the Sisters of the Holy Cross. (LOC.)

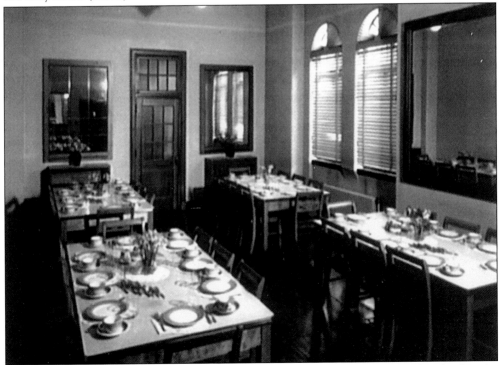

The simple dining hall at Dunbarton College (Holy Cross) was pictured here shortly after the college opened its doors to Washington's elite in 1935. (LOC.)

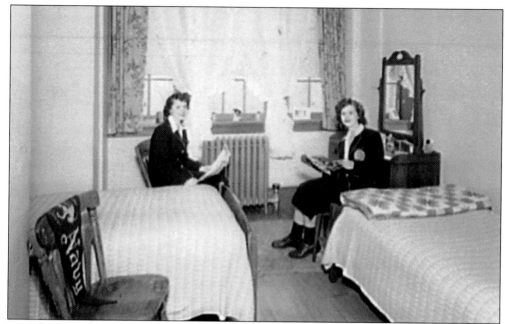

Students are pictured here in their dormitory at Dunbarton College (Holy Cross). The student rooms traditionally had two students in each room with two beds, one dresser, and a couple of chairs. (LOC.)

A game on the hockey field at Holy Cross College is monitored by three nuns, who were also physical education teachers. Note that in the background, only one house appeared on Upton Street at the time. (LOC.)

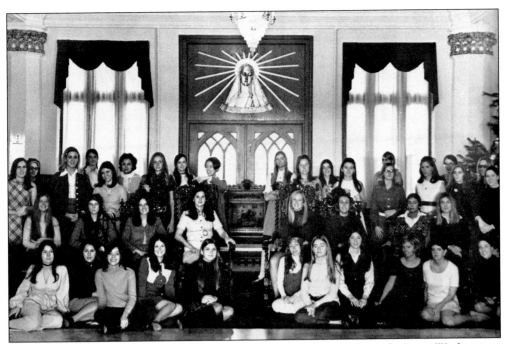

Pictured here is the 1971 graduating class of Dunbarton College of the Holy Cross, Washington, D.C. The college opened in 1935 and operated at this campus for 38 years, until May 1973. (Photo donated by Kathleen M. Higgins, sixth from the right, back row.)

The students of Dunbarton College take over the Budweiser delivery truck for a class photograph in 1971, two years before the college closed. The building is utilized today by the Howard University School of Law. The former chemistry building at 2955 Upton Street has served as the home of the Edmond Burke School since 1973. (Authors.)

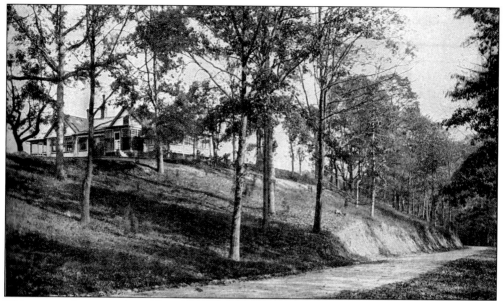

This country home was listed for sale in 1918. It was described as three miles north of the Capitol Building, abutting onto Rock Creek on the western edge of Cleveland Park. The advertisement boasted of the property's modern amenities such as city water, electricity, trash, and sewage, as well as telephone service. The 20-acre grounds included 500 rose bushes; a 5-acre lawn; an acre of "old-fashioned" flower gardens; 200 fruit trees; a quarter-mile private macadam entrance road; old oak, walnut, and hickories trees; a separate house for tenants; and commanding views of Rock Creek Park on all sides. (Authors.)

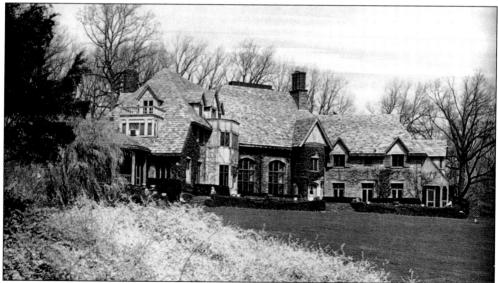

This 59-room stone mansion at 4400 Broad Branch Road was designed by Russell O. Kluge and constructed in 1927 on 22 acres of rolling land adjacent to Rock Creek Park for Mrs. Arthur O'Brian. The architect incorporated rich library paneling from Sir Christopher Wren's own study in London. The mansion was known as "Estabrook" until 1941 when it was purchased by Col. and Mrs. Robert Guggenheim and renamed "Firenze," after their previous abode—a large yacht that had been commandeered by the United States Navy for wartime service. (LOC.)

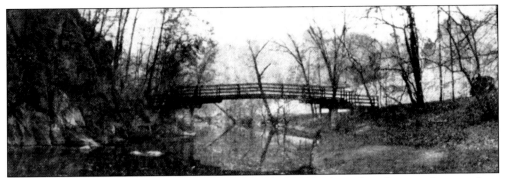

This bridge was destroyed in a flood sometime after 1932 when this photograph was taken. Today, only its foundations, south of Peirce Mill, can be seen. (LOC.)

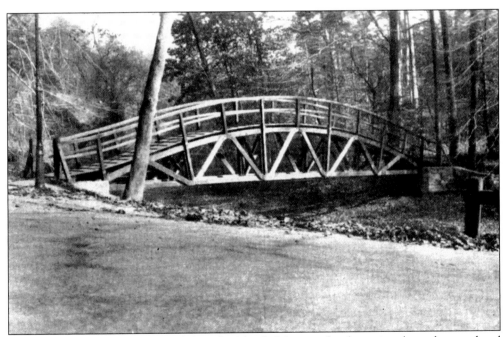

The old bridge over Rock Creek, below the Klingle Mansion, has long since been destroyed and replaced by a less ornate footbridge. This type of bridge is known as a Bowstring bridge. (LOC.)

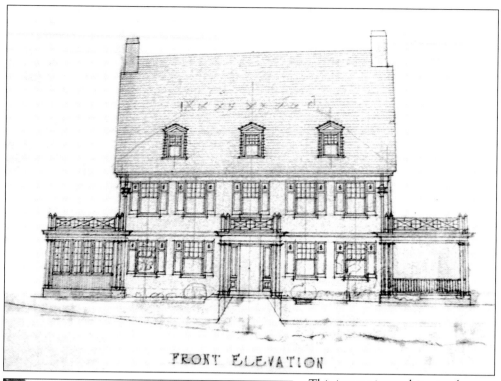

FRONT ELEVATION

This impressive architectural drawing was for a house built for George W. White at 2800 Upton Street in the 1920s. White was president of the National Metropolitan Bank and president of the Potomac Insurance Company. (LOC.)

The Cleveland Park Congregational Church at 34th and Lowell Streets was organized in 1918 and later dedicated this church in 1923. The development firms of W.C. & A.N. Miller financed it. (LOC.)

Five

COMMERCIAL CORRIDORS

Interestingly, much of Cleveland Park's commercial core was built long after the area was home to hundreds of families at the turn of the 20th century. At that time, residents typically traveled all the way to 18th and Columbia Streets for the closest drugstore, for example, to aid them in battling the 1918 influenza epidemic. The first stores that served the community appeared on Wisconsin Avenue, and in the 1920s, many were simultaneously constructed along Connecticut Avenue.

In 1920, the city's first zoning law was passed that specifically limited four areas along the entire length of Connecticut Avenue to be designated as shopping districts, with all others to remain residential in nature. One such area along the corridor was in central Cleveland Park. A short time earlier, in 1916, the firehouse was constructed along Connecticut Avenue and signaled a rapid growth in retail and entertainment venues along the street. The Monterey Pharmacy was one of the first such establishments, opening its doors in the Monterey Apartment building in 1923. Seven stores at Connecticut Avenue and Macomb Street were built for architect George N. Ray in 1926, and many others followed suit designed in the Art Deco style.

The largest and perhaps most unique commercial venture in Cleveland Park was the Park and Shop, which opened in 1931. Designed by Arthur B. Heaton for a local development company, it was actually constructed as a new prototype building that encouraged automobiles to enter the site and their drivers to shop in what would become of the first "strip" malls in America.

The opening of the famous Uptown Theater in 1936 has cemented the commercial corridor along Connecticut Avenue ever since as a destination and entertainment district for locals and city dwellers alike. The post office opening in 1940 and the library opening in 1952 seemed to complete the vital commercial core that was ultimately complemented by the Metro opening its doors in 1981.

Most of the eastern side of Connecticut Avenue was developed in 1926, with the Art Deco–style City Bank building being one of the tallest structures. In 1930, businesses included the Great A&P Tea Company, Palace Laundry, Singer Sewing, Arthur Joll Cigars, and Sam Silverberg's Hardware Store. (LOC.)

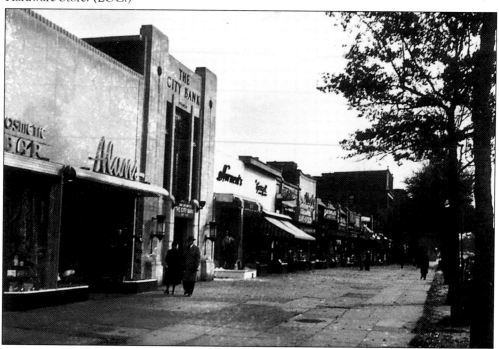

The east side of Connecticut Avenue between Macomb and Ordway was photographed on November 24, 1949. Many of the storefronts featured extensive Art Deco detailing in raised relief panels, a few of which can still be found to this day. (HSW.)

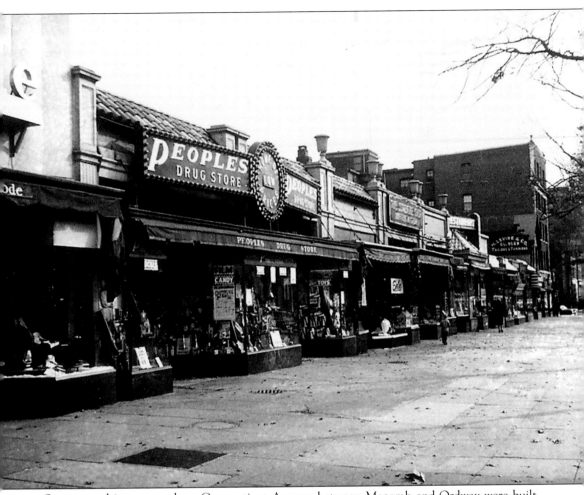

Seven matching stores along Connecticut Avenue between Macomb and Ordway were built by architect George N. Ray in 1926. They featured extensive glass transoms and coordinating advertising canopies, along with decorative urns along the rooftop. They were captured in the picture seen here dated November 24, 1949. (HSW.)

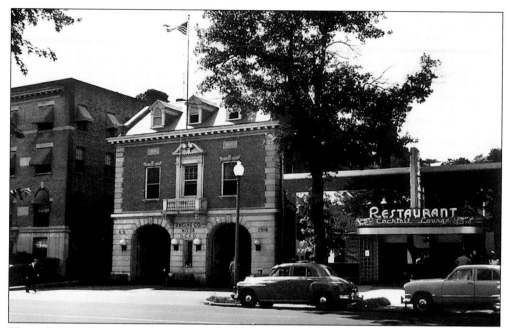

The well-known fire station and Chinese restaurant on Connecticut Avenue were photographed on September 16, 1951. The firehouse had been built in 1916 to the designs of architect Snowden Ashford. The Yenching Palace at 3524 Connecticut Avenue has been a fixture in the neighborhood since the 1940s. It was the covert meeting place between ABC newsman John Scali and Aleksander Fomin of the Soviet Union during the 1962 Cuban Missile Crisis. The restaurant played an important role in the relationship between the United States and China in the 1970s, as the press conference for the arrival of two giant pandas at the National Zoo was held there. (HSW.)

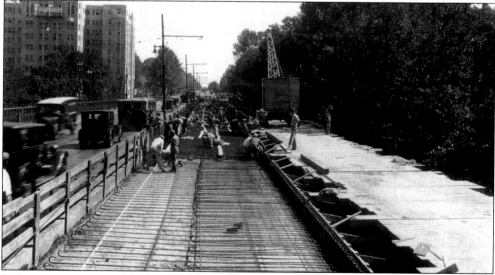

Eight stone urns topped by bronze-fitted lamps decorate the end posts of the Klingle Bridge. The urns were designed to resemble miniature lighthouses, while Art Deco detailing also was used for decoration. The bridge cost $458,951 to build; the original 1891 steel truss bridge had cost a mere $35,000. This construction photograph was taken in September 1931. (LOC.)

This detailed drawing for the Park and Shop is housed at the Library of Congress and was created by architect Arthur B. Heaton, his commission number 3,001. The drawing itself was completed in 1930, and the complex opened just a year later. (LOC.)

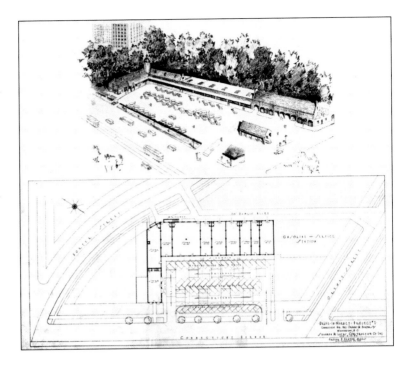

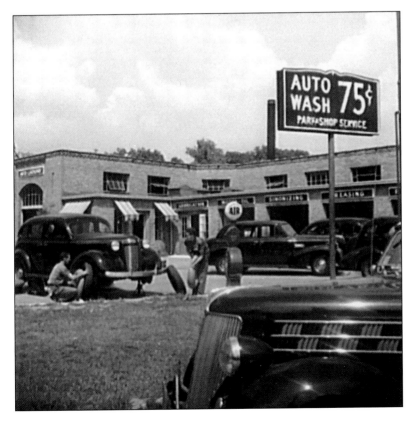

A few Cleveland Park residents may remember that a portion of the Park and Shop featured a car wash and service area, located at what is now a Pizzeria Uno. Edwin Rosskam took this photograph of the car wash in September 1940. (LOC.)

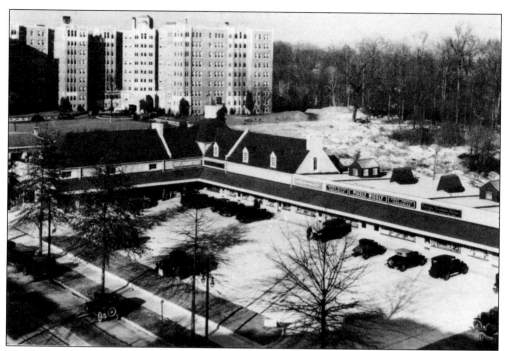

The Park and Shop is shown here with some of its original tenants, the Piggly Wiggly supermarket and "Baker and Bakery." The complex was innovative in its design as one of the earliest to accommodate automobile traffic and was commissioned by the real estate firm of Shannon and Luchs. It was built as a prototype representing a new building type. (LOC.)

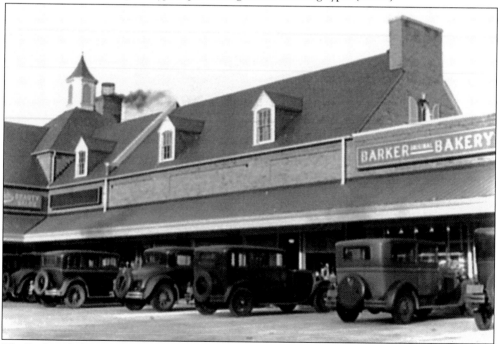

The Park and Shop is seen here not long after it opened in 1931. It was an instant success, since its intended automobile shoppers easily found parking in front of each establishment. (LOC.)

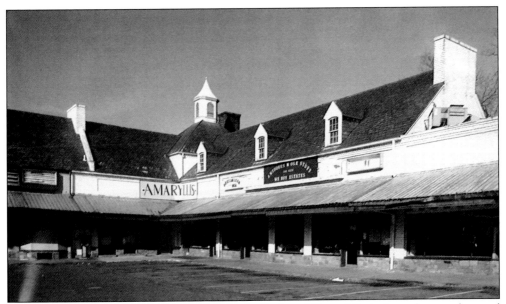

Like many early suburban shopping centers, the Park and Shop fell victim to larger urban and suburban malls and came upon hard times in the 1970s. It was documented and researched by the Historic American Building Survey (HABS) in 1980, at a time when it was repeatedly threatened by demolition. (LOC.)

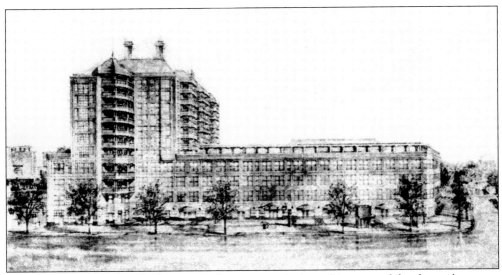

Cleveland Park residents had reason to be concerned when this proposal for the replacement building on the site of the Park and Shop was suggested. It was to include neighborhood-oriented retail shops, 254 underground parking spaces, and housing and office space developed by the Urban Group. Proposed in 1988, it galvanized the neighborhood and the Cleveland Park Historical Society to preserve and rehabilitate the existing building. (CPHS.)

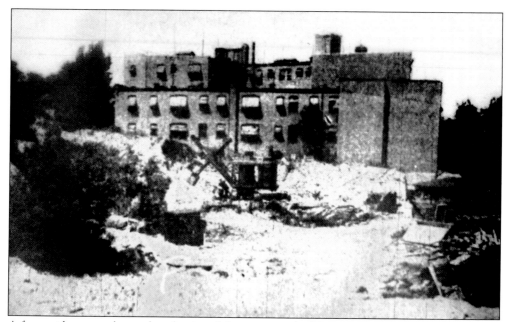

A few residents may know that the site of the ever-popular Uptown Theater was actually a large open stone quarry, providing the local building material for many of the community's homes and even the Congregational Church at 34th and Lowell Streets. This rare image captures a steam shovel in the snow lifting freshly cut blocks of stone from the bed of the quarry. (MLK.)

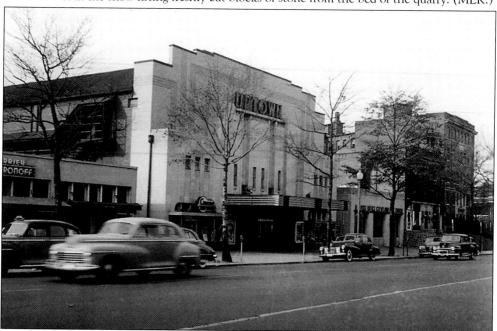

City commissioner Melvin Hazen orchestrated the 1936 opening of the beloved Uptown Theater. Much later, the opening of *Star Wars* is remembered by residents and described by the *Washington Post* as "The movie that ate Cleveland Park," referring to the horrific traffic jam that ensued. The Cleveland Park post office, seen on the right, opened in 1940. The photograph here was taken on November 24, 1949. (HSW.)

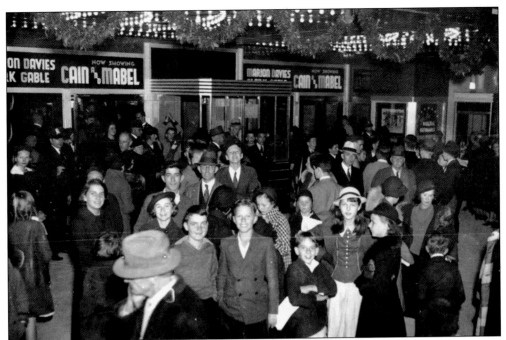

The Uptown's opening night crowd was captured here in 1936 outside the theater, waiting for the movie entitled *Cane and Mabel*, starring Marion Davies and Clark Gable. Longtime residents will remember the yo-yo contest that was held before every matinee; in 1988, the *Hollywood Reporter* rated the theater second in a national search for the best single-screen movie theater. (MLK.)

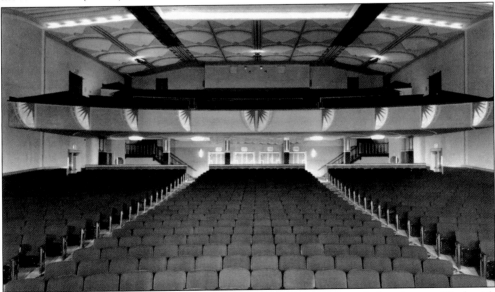

The original interior décor of the Uptown Theater is seen here before it was filled with the opening-night crowd in 1936. It was designed by architect John Jacob Zinc to be a "move over" house to show second-run shows that had originally played at the Ontario Theatre on Columbia Road. It has since been the theater of choice for numerous Hollywood premiers. (MLK.)

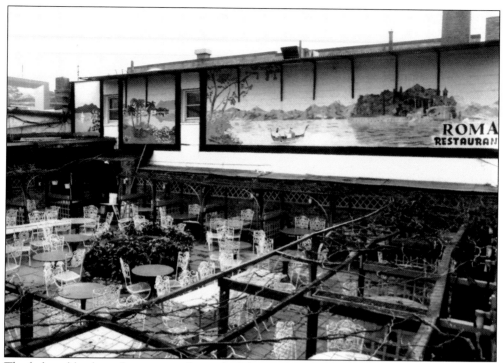

The beloved back garden room and mural of the Roma Restaurant was photographed shortly before the property was subdivided and the garden leased to Firehook Bakery. It had been a mainstay in the Cleveland Park neighborhood for over 40 years. (Authors.)

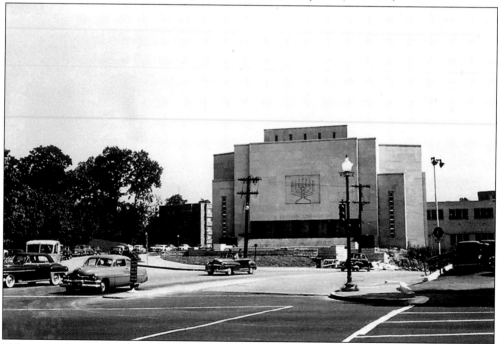

Taken just after its completion, this image shows the New Adas Israel Synagogue at Connecticut Avenue and Quebec Street on September 16, 1951. (HSW.)

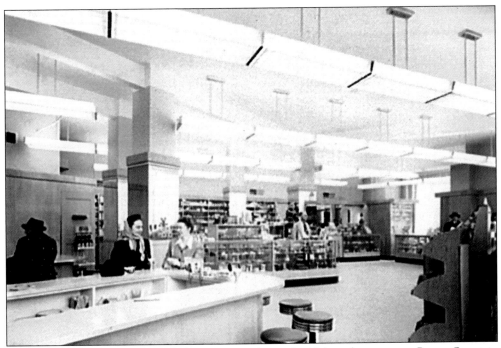

This spacious diner counter and pharmacy was located within a drugstore on Porter Street in Cleveland Park. (LOC.)

Streetcars with overhead electrical cables were once a common sight all over Washington, with this one taken at Wisconsin Avenue and Idaho Street on May 3, 1947. The newly built apartments on the old Friendship estate can be seen in the background. (HSW.)

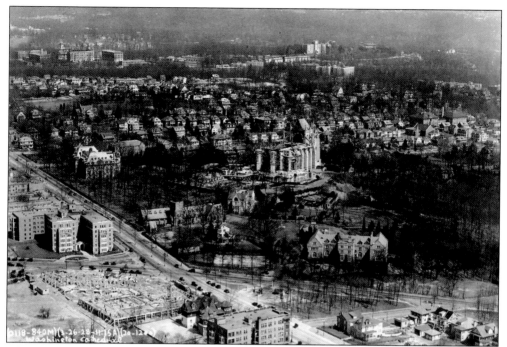

Almost all of Cleveland Park was captured in this aerial photograph taken in the late 1920s. The large elaborate house at the lower center of the image was the old St. Albans Boys School. (NCA.)

Reservation 700 was renamed Lord Bryce Park in honor of the British ambassador to the United States between 1907 and 1913. The park is located at Wisconsin and Massachusetts Avenues and was dedicated by Princess Margaret of Great Britain. This image appeared in the *Washington Post* on March 19, 1962. (Photograph by Jim McNamara.) (MLK.)

Six

APARTMENT HOUSES

During the 1920s, 1930s, and early 1940s, the density of the population living in Cleveland Park increased with the construction of the neighborhood's several large apartment buildings. Despite the few number of actual apartment buildings erected, Cleveland Park underwent a significant transformation due to the size of each massive yet elegant apartment building.

Spurred in part by the construction of the Taft Bridge in 1907 and the subsequent housing boom of the 1920s, Washingtonians began to take notice of outer suburbs such as Woodley and Cleveland Parks with their growing commercial areas and proximity to such attractions as Rock Creek Park, the National Zoo, and the Washington Cathedral. To meet the needs of the somewhat new housing type, prominent architects and developers took the initiative to construct several large apartment buildings that contained features and architectural elements not found in the ordinary house.

The Tilden Gardens apartments was one of the first major complexes to appear, beginning in 1927 as a co-operative venture. Seven buildings in all completed the complex, designed by the architectural firm of Parks and Baxter. Despite the Great Depression, building commenced on such impressive apartment buildings as the Broadmoor, completed in 1929 and home to many of Washington's influential families ever since. Sedgwick Gardens apartments, completed in 1931, featured an interesting blend of Moorish and Art Deco elements in its design by Mihran Mesrobian, a favorite hotel architect frequently hired by well-known developer Harry Wardman. Smaller apartments have made their way into the lifestyle of Cleveland Park residential areas to create a rather utopian blend of homeowners and apartment dwellers that continues to exist to today.

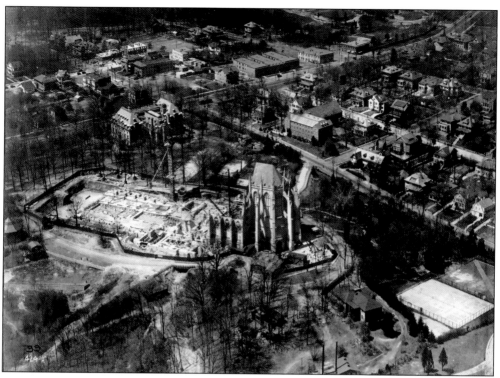

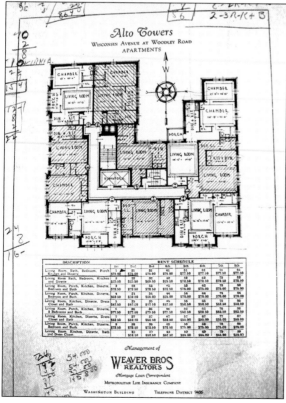

The lower nine holes of the 18-hole Friendship golf course made up the western boundary of Cleveland Park in the 1920s. The above image, commissioned on May 23, 1923 by the George A. Fuller Company (who was responsible for building the National Cathedral), shows how little development had occurred west of Wisconsin Avenue by that point. Yet it was an area that was soon to be spotted by large-scale apartment complex developers. (NCA.)

The Alto Towers apartment floor plan and rent schedule indicates that apartments ranged that year from $47.50 to $77.50 based on size, efficiencies, number of bedrooms, and location. The upper floors demanded the highest rent. (LOC.)

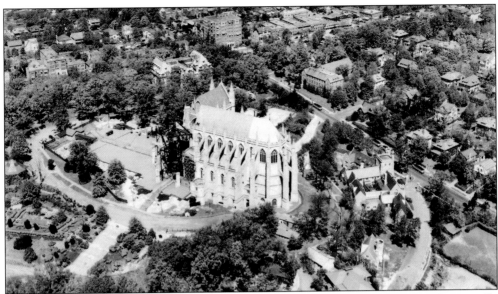

This May 11, 1935 image from the Fairchild Aerial Survey Company, taken over the partially complete National Cathedral, encompasses portions of the Cathedral close, Cleveland Park, American University, and the Friendship estate. It shows how many vacant lots and forested areas remained at the time. However, they would quickly be developed into apartment buildings and areas for additional housing. (NCA.)

These series of apartments were built as co-operatives at 3018–20–22–24–26–28 Porter Street and designed by architect James E. Cooper. They were built by the Warren Brothers, Monroe & R. Bates in 1924 as distinct and individual cooperative companies. The original sale price for each unit was between $5,800 and $7,500 and included a series of stylish garages, one for every other unit. To this day both the landscaping and detail of the buildings remain much as they were in 1924. (Smithsonian.)

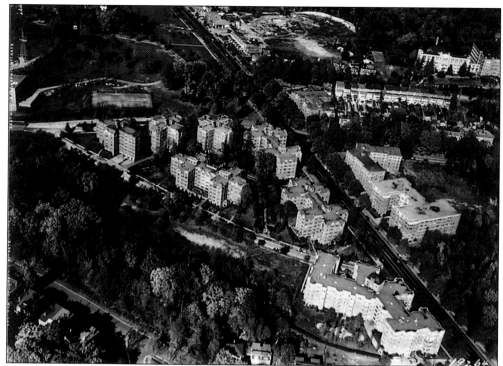

This aerial view of Connecticut Avenue and the National Bureau of Standards shows the homes and vacant lots where massive apartment buildings such as the Tilden Gardens and the Broadmoor would eventually be erected. (HSW.)

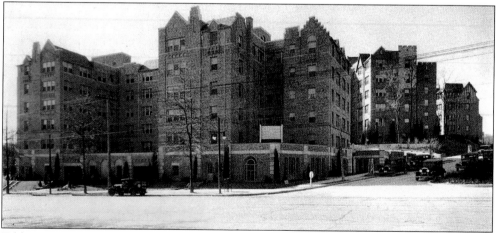

Tilden Gardens apartments at 3000 Tilden Street occupies the site of one of Cleveland Park's oldest homes, that of John Adlum, which was razed in 1911. The first of Tilden Garden's six buildings was started in 1927 with the "A" and "B" buildings along Tilden Street, which were owned as co-operatives. The other five buildings followed from 1929 to 1930 and were operated as rental units until 1939, when the contemporary Tilden Gardens co-op was created and incorporated all six buildings. They were built at a cost of $3 million and designed by the architectural firm of Parks and Baxter. Monroe Warren and his brother R. Bates Warren built them. The brothers had purchased the land from the Chevy Chase Land Company. (Smithsonian.)

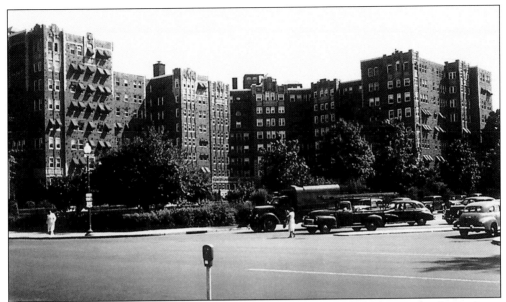

This 1945 image shows the Broadmoor apartment building shortly before it was changed to a co-operative building with 194 units. The Broadmoor was designed by Joseph Abel, who also designed the famed Shoreham Hotel in Woodley Park. The Broadmoor opened in 1929 with 179 units and housed a beauty parlor, pastry shop, and valet and laundry services. (HSW.)

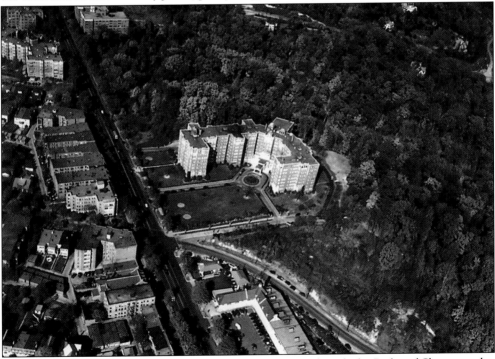

The Broadmoor is seen in the middle of this aerial photograph with the Park and Shop complex to the south. Little else is in the vicinity of the impressive apartment building except a heavily wooded area. The Broadmoor's design resembles a hotel, and, in fact, was named after a luxury hotel in Colorado Springs, Colorado. It was built for just $2 million in 1929. (Smithsonian.)

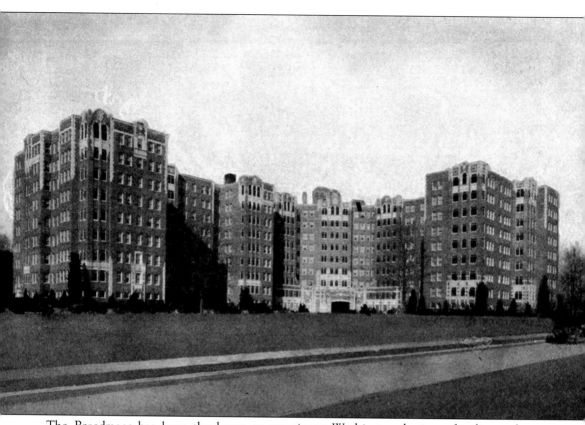

The Broadmoor has been the home to prominent Washington business families such as the Hechingers and the Mazors, as well as President Richard Nixon, who lived there in 1947 while looking for a house. It was pictured here along Quebec Street the year it was completed, 1929. (MLK.)

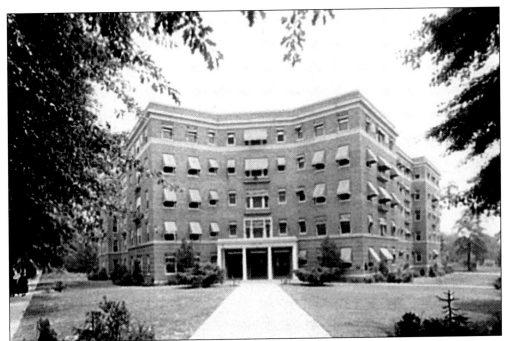

Noted photographer Theodor Horydczak captured the exterior of Tilden Hall apartment complex at 3945 Connecticut Avenue, c. 1930. It had been built in 1922 as a 65-unit apartment building, one of the largest built in Cleveland Park up until that time. (LOC.)

The lobby of Tilden Hall at 3945 Connecticut Avenue appears to reflect a simple yet understated entrance when it was photographed c. 1930 by Theodor Horydczak. The building stood out in contrast to other more lavish and decorative apartments that would be built in Cleveland Park during the era. (LOC.)

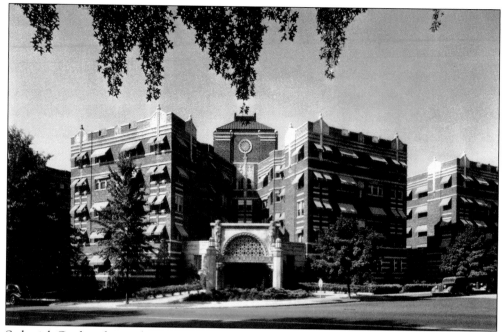

Sedgwick Gardens featured an interesting blend of Moorish and Art Deco elements in its design, as seen here in this photograph of the front façade. The apartments, located at 3746 Connecticut Avenue, N.W., were designed by Mihran Mesrobian in 1931 and built by Max Gorin of the Southern Construction Company for $500,000. The building featured parking spaces for 16 cars in its basement, which was considered innovative at the time. (Smithsonian.)

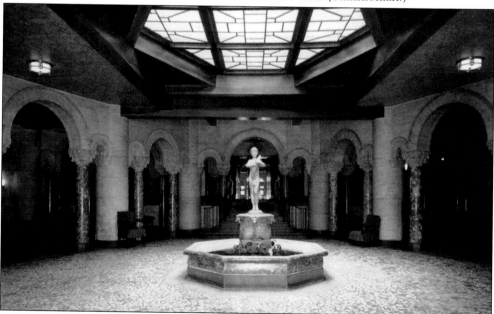

The impressive Art Deco lobby at Sedgwick Gardens features solid mahogany doors, solid brass hardware, and ample limestone and marble. The oversized octagonal lobby was also accented by two dozen Moorish-style arches and columns. A unique sprinkler system on the roof was developed to cool the upper floor apartments during the city's hot summers. (Smithsonian.)

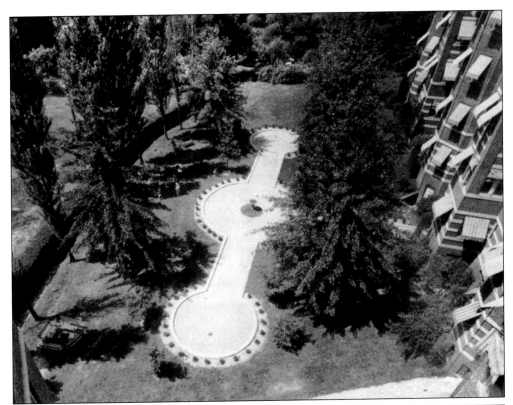

An elegant garden, featuring this fountain, as well as a children's playground were found on the expansive lawns of the Sedgewick Gardens apartment complex upon its completion in 1931. Many of its apartments featured a newly available "Murphy Bed" cleverly concealed in smaller apartment walls. (Smithsonian.)

Architect Donald H. Drayer designed the Quebec House apartment building for the Randall Hagner Company at 2801 Quebec Street. His concept for the front entrance design is seen here. (LOC.)

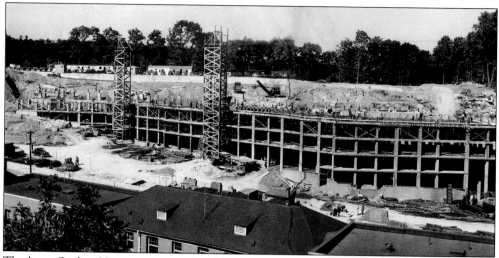

The large Quebec House apartment building along the 2800 block of Porter Street is seen here during construction on September 23, 1945. (MLK.)

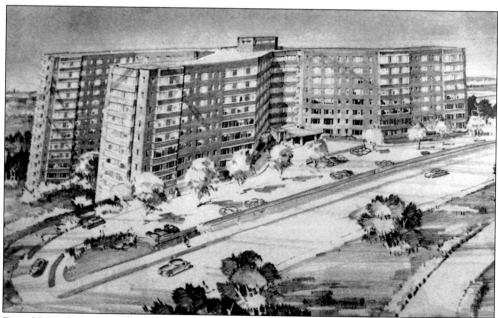

Donald H. Drayer designed the Quebec House apartment building for the Randall Hagner Company at 2801 Quebec Street. His 1950 perspective of the building is seen here, when the area east of Connecticut Avenue served as one of the last undeveloped areas available for such large-scale projects. (LOC.)

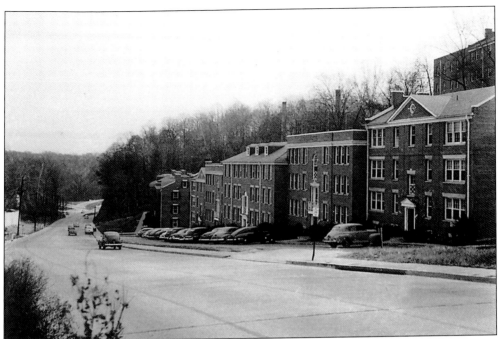

This series of smaller-scale apartment buildings along the 2800 block of Porter Street, east of Connecticut Avenue, was photographed shortly after its completion on November 24, 1949. (HSW.)

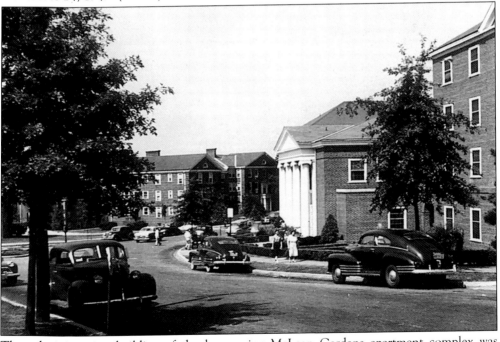

The administration building of the burgeoning McLean Gardens apartment complex was photographed near Porter Street and Wisconsin Avenue on July 30, 1949, several years after the former Friendship estate had been converted into permanent homes for Washingtonians remaining in the city following World War II. (HSW.)

The Macklin Apartments at 2911 Newark were built in 1939 as an 18-unit building tucked into a formally unused building lot. (Authors.)

Despite being built in 1939, the architectural details from the Macklin Apartments at 2911 Newark featured the fine streamlined Art Deco detailing seen here. The attention to detail represents a building era and construction techniques that have, over time, been recognized. The quality of these buildings have galvanized Cleveland Park residents to protect and preserve their architectural heritage and sense of place from encroachment and unwarranted development. (Authors.)